POWER MODE

POWER MODE
THE FORCE OF FASHION

Emma McClendon

SKIRA

Cover
Reebok by Pyer Moss Collection 1
Photo courtesy of Pyer Moss
shot by Maria Valentino

Design
Marcello Francone

Editorial Coordination
Emma Cavazzini

Editing
Emanuela Di Lallo

Layout
Barbara Galotta

Photo Credits
Photograph © The Museum at FIT

First published in Italy in 2019 by
Skira editore S.p.A.
Palazzo Casati Stampa
via Torino 61
20123 Milano
Italy
www.skira.net

Printed and bound in Italy.
First edition

ISBN: 978-88-572-3987-3

Distributed in USA, Canada,
Central & South America
by ARTBOOK | D.A.P. 75,
Broad Street Suite 630,
New York, NY 10004, USA.
Distributed elsewhere in the
world by Thames and Hudson
Ltd., 181A High Holborn, London
WC1V 7QX, United Kingdom.

CONTENTS

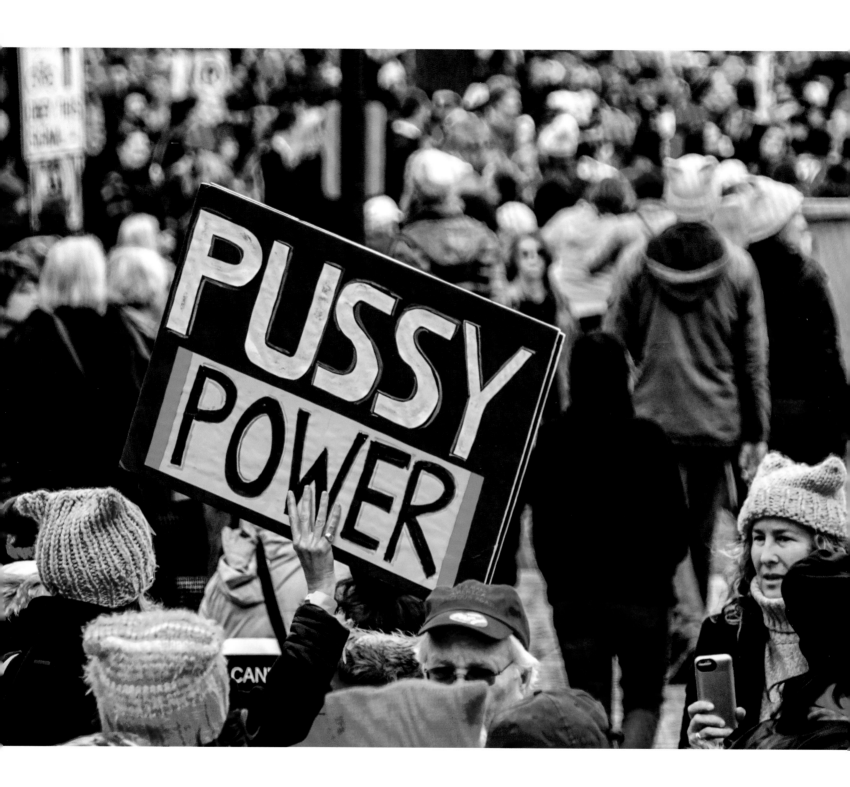

INTRODUCTION

Emma McClendon

The word "power" frequently appears in discussions of fashion—power dressing, power heels, the power suit—but what do these terms actually mean? What makes a suit or a heel "powerful"? To grapple with this question, *Power Mode* begins with objects. It considers fashion items that are often interpreted as "power" statements—from gray flannel suits to latex fetish wear, and from gilded brocades to distressed jeans—analyzing them in tandem with theory and history. This approach may inevitably raise more questions than answers. But the goal is to provide a tool kit for understanding the "power" inherent in modern fashion. This, in turn, may shed new light on the role fashion plays in establishing, reinforcing, and challenging power dynamics within society more broadly.

Today, we see a multitude of sartorial power symbols, ranging from the pink DIY "pussyhats" at the 2017 Women's March to the Cleveland Cavaliers' coordinated Thom Browne suits worn during the 2018 NBA playoffs—LeBron James and his teammates filed off their bus ahead of game one in the finals wearing head-to-toe Browne looks. A *New York Times* article remarked that "arena arrivals have long been fashion runways for N.B.A. superstars," but the "Cavaliers took things to a new level."[1] It was a pre-game power move, a fashion statement as power statement. However, the Cavaliers' coordinated suits had curious proportions: they were tight, short, and shrunken—decidedly more "feminine" and adolescent than the prototypical power suit. While immediately recognizable as Browne's work, they struck many as an odd choice for the hyper-masculine space of a sports arena. Still, the uniformity and style of the team's entrance made a powerful impression.

Fashion journalist Vanessa Friedman expressed her confusion at defining contemporary power dressing by referencing Supreme Court Justice Potter Stewart's quip about hard-core pornography: "I know it when I see it."[2] This may indeed be our experience in daily life—we recognize power dressing when confronted with it—but, again, what makes a garment

◀ Protesters during the Women's March on Washington in Washington, D.C., January 21, 2017. Photo by The Photo Access/Alamy Stock Photo

▶ LeBron James arriving at game one of the 2018 NBA Finals wearing a custom Thom Browne suit, May 31, 2018. Photo by Guy Marineau/Condé Nast via Getty Images

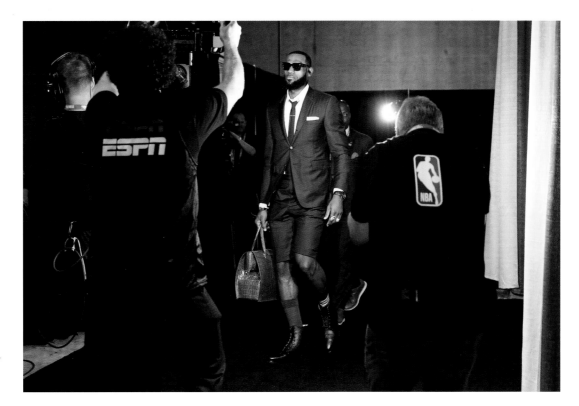

"powerful"? And perhaps more important, does a garment itself even have power, or is it the wearer who has power, and the garment merely an instrument or weapon of power?

If we think of power in terms of kinetic force (for example, electrical power or a person's physical power over another), clearly an inanimate item of clothing does not have actual power. The power of fashion is symbolic. It is social. It lies in the sphere of interpersonal relations and cultural dynamics, which is much more difficult to measure than kinetic force. It is related to political position and economic status, but also to military strength, sexual authority, rebellion, and protest. Power, in this sense, is part personal identity, part behavior, and is often conveyed through a mix of action and visual expression. Many different (and opposing) definitions of social power have developed over the centuries. These voices make up what might be called the "power theory debate," which offers varying perspectives for understanding the power dynamics of fashion.

THE POWER THEORY DEBATE

Finding a single definition of social power has confounded philosophers for millennia. From Plato and Aristotle to Foucault, they have always found little consensus. As sociologist and political theorist Steven Lukes explains, "We speak and write about power, in innumerable situations, and we usually know, or think we know, perfectly well what we mean . . . And yet, among those who have reflected on the matter, there is no agreement about how to define it, how to conceive it, how to study it and, if it can be measured, how to measure it."[3] Power, in this sense, could be compared to air—it exists all around us at any given moment, but when we are asked to grasp it, to point to it, it proves elusive.

Lukes maps out many facets of the power theory debate in a recent edition of his treatise *Power: A Radical View*. Most of the definitions come from political theorists. For Thomas Hobbes, social power was about securing "the way of . . . future desires."[4] Max Weber discussed power as "getting what one wants,"[5] while Robert Dahl viewed it as an issue of desire, behavior, decision-making, and direct conflict in which "*A* has power over *B* to the extent that he can get *B* to do something that *B* would not otherwise do."[6]

The difficulty in applying many of these approaches to a study of fashion stems from the fact that most of these political authors wanted not only to define power theoretically, but to do so in a way that would allow them to measure it and evaluate its outcome in political structures. I am not concerned with measuring how much power any single garment may (or may not) hold in comparison to another, or with empirically quantifying what tangible outcome might come from wearing a particular garment. I am more interested in asking why we consider clothing to be related to power dynamics at all and in exploring the ways both wearers and designers use clothing as a tool to grapple with power structures in everyday life.

Of course, desire and conflict remain important considerations in an examination of power and fashion. Hobbes's belief that a person reaches for power in order to secure "the way of his future desires" could be considered the underlying principle behind the contemporary power-dressing mantra, "Dress for the job you want, not the job you have."

Yet more important to this discussion is the work that has emerged from sociology and cultural anthropology. Indeed, Lukes argues for a "sociological perspective" in the study of power.[7] He believes in taking what he calls a "three-dimensional view"[8] in order to "broaden and deepen the scope of the analysis."[9] What this means is that he is interested in the less easily measured power dynamics that play out in everyday decision-making, cultural interests, etc. This approach connects to sociologist Pierre Bourdieu's theory of "habitus," a term he assigns to the cultural matrix of a person's material surroundings, including norms, behaviors, practices, and judgments that an individual is immersed in from birth. Habitus latently determines a person's preferences, and even life choices, without the individual being aware of the influence.[10] It also connects to Daniel Miller's theory of "self-making," or how an individual constructs personal identity through consumption with the things they buy and

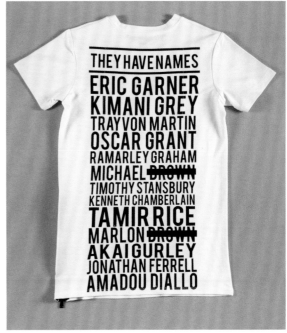

surround themselves with.[11] These approaches go beyond the concept of power as desire and direct conflict to consider how power dynamics exist within society, and material culture more broadly, in a way that constantly surrounds us whether or not we are aware of it.

Much of the power theory debate pivots on the idea of power as domination. Bourdieu outlined habitus in a book titled *Distinction*. At the heart of his approach is the belief that an individual is inherently subject to domination in daily life. For Bourdieu, fundamental to "social order [is] the opposition between the dominant and the dominated," or "between the 'elite' of the dominant and the 'mass' of the dominated."[12] According to this view, only the dominant have power.

Michel Foucault is the most famous promoter of power as domination. Like Bourdieu, Foucault took a purposefully broad approach in his analysis of power. He recognized that "power is a pervasive aspect of social life and is not limited to the sphere of formal politics or of open conflict."[13] In his book *Discipline and Punish*, Foucault lays out his theory of "disciplines" and "docile bodies" that keep individuals under control and maintain social order, even as individuals remain unaware that they are under control. It is a theory of our social system as one of complete domination. As Lukes explains, Foucault's is an "ultra-radical" view that has been "taken to imply that there is no escaping domination, that it is 'everywhere' and there is no freedom from it or reasoning independent of it."[14] Foucault was writing during the 1970s and 1980s, and the influence his writing has had on power theory cannot be over-emphasized. But there is an issue with Foucault's approach when it comes to the question of resistance.

The problem with defining power solely as domination is that this does not allow for the resistance by individuals—or "agency"—to be understood as a form of power. But agency is incredibly important to the way many clothing items are interpreted as "powerful." If agency is not power, what, then, can we say of the hundreds-of-thousands of "pussy"-hat-wearing female protesters who stormed Washington, D.C.—are they powerless because they are technically under the authority of the dominant conservative, male president? Or how can we discuss the moment when young, black designer Kerby Jean-Raymond, wearing a T-shirt emblazoned with the names of other young, black men who had been victims of police violence, met with members of the fashion media? Does this action have no power because of the white-dominated nature of the fashion industry and American society?

Lukes cites the work of political scientist James Scott on the power of resistance. Scott lays out a theory of "public" and "hidden" transcripts, which argues that the traditional Western

▲ Kerby Jean-Raymond at the spring 2016 presentation of his Pyer Moss collection wearing a shirt of his own design printed with the names of young black men recently killed by police. Photo by Benjamin Lozovsky/BFA. com. Right: Pyer Moss by Kerby Jean-Raymond, T-shirt, white viscose, spring 2016, USA, The Museum at FIT, 2016.83.3, Gift of Pyer Moss

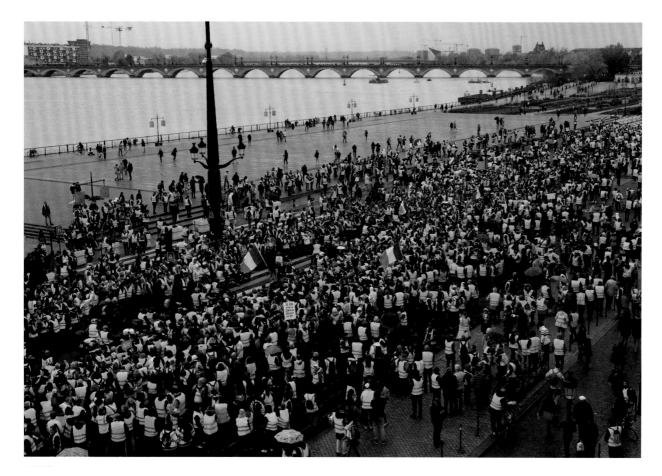

understanding of power as domination is inherently biased. The acts of dominant groups are performed out in the open, while the acts of subordinate individuals are purposely hidden from view, and, as such, are much less likely to be analyzed and understood as "powerful." This has led to the assumption that subordinate individuals have no power, when, in fact, it's the nature of their power that is different.[15] Perhaps the simplest way of conveying what Scott means is by referencing the Ethiopian proverb he uses to open his book: "When the great lord passes, the wise peasant bows deeply and silently farts."[16]

Of course, Scott's "hidden" forms of resistance are, by their nature, obscured from view to avoid detection and, therefore, his analysis does not include discussion of overt sartorial statements. More recently, scholars have noted the evolving nature of resistance made apparent by the Arab Spring, Women's March, and Gilets Jaunes (Yellow Vests) protests. Erica Chenoweth lays out a framework for understanding this new form of highly visible, coordinated "civil resistance" in her work.[17] It is a type of resistance based in harnessing visual and digital tools in order to subvert the dominant hierarchy of society. Both Scott and Chenoweth question the very foundations on which the power as domination theory has been built by reframing the position of resistance, which proves useful when considering the role resistance plays in fashion.

Power's relation to fashion goes beyond tangible outcomes and binary conflicts. It is personal and public, group and individual, or, as Bourdieu once wrote, it relates "inside to outside . . . being to seeming."[18] There is no single, universally accepted definition of power. Power means different things to different people at different times. As such, its connection to fashion is multifaceted.

POWER IN FASHION

Many fashion scholars have touched on power in their work. For example, in Anne Hollander's influential book *Sex and Suits*, power is key to understanding the suit's significance in the history of modern clothing. As she describes it, the suit is part of "the fantasy of modern form," where it becomes "the proper material vessel of both beauty and power..."[19] The issue with such statements is that they presuppose a common understanding of power. This speaks to Lukes's

◀ Gilets Jaunes (Yellow Vests) protest against fuel prices in Bordeaux, France, December 1, 2018. CAROLINE BLUMBERG / EPA-EFE/Shutterstock

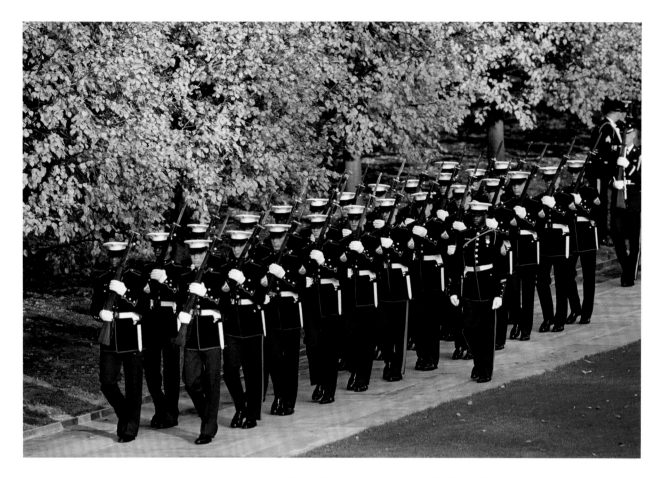

observation that when we refer to power, we typically "think we know, perfectly well, what we mean," but the task of defining it proves much more complicated.

The relationship between power and fashion is most often discussed as a relationship between meaning and symbol—an item of clothing is not power itself, but rather a tool, or, to take Hollander's words, a "material vessel" for expressing power. It is a mechanism by which power relations are read and understood in social spaces. As Lukes describes, "We need to know our own powers and those of others in order to find our way around" and navigate "hypothetical conditions."[20] Clothing helps us do this.

This understanding of fashion items as "vessels" of meanings connects to semiotics, a field of cultural analysis that examines society as a complex system of relationships between signs and what they signify. As Fred Davis explains, "In everyday face-to-face interaction, the clothing-fashion code is highly context-dependent . . . While the signifiers constituting a style . . . can in a material sense be thought of as the same for everyone (the width of a lapel, after all, measures the same in Savile Row as in Sears) what is *signified* (connoted, understood, evoked, alluded to, or expressed) is, initially at least, strikingly different for different publics, audiences, and social groupings."[21] Davis's observation on the different things suits can signify highlights the fact that power in fashion is not strictly binary—an item does not exist in a controlled setting of wearer vs. viewer or designer vs. wearer. Instead, it moves through social spaces and exists in a dynamic position to myriad individuals.

This dynamic position becomes more complex as we begin to map out the different "types" of power that clothing is thought to signify. On the one hand, power dressing is in fact about domination when we consider a uniform on a military base or a sharply tailored suit in a board room. These types of garments are designed to express authority, both literally and metaphorically.

Status dressing is also another expression of power as domination. Bourdieu made this connection by rooting habitus in tensions between the "elites" and the "mass" population. Likewise, American economist and sociologist Thorstein Veblen was fascinated by what he termed "conspicuous consumption"—the highly visible consumer habits of the wealthy elite at the

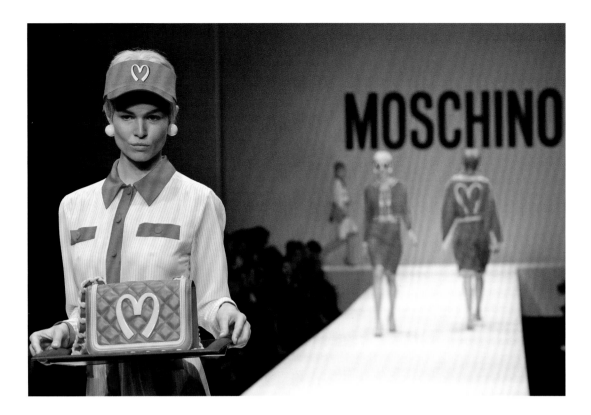

turn of the twentieth century—which he viewed as a performance of status.[22] Today, branding rules conspicuous consumption on the runway and in the digital spaces of street-style photography and social media.

But the power of clothing is not always about domination; "powerful" garments are often described as a form of protection or "armor." Indeed, Bill Cunningham once asserted, "Fashion is the armor to survive the reality of everyday life," defensive cladding to make you feel stronger. Some protective power outfits are quite literal, alluding to the shiny metal of medieval suits of armor or the ribbed breastplate of samurai warriors. But the woman's "power suit" can also be considered a form of sartorial protection within the male dominated space of an office, giving the wearer strength by sheathing her body in the visual language of male authority.

There is also the power to be heard and seen, the power to choose your own ensemble, the power to build your own identity—in other words, power as "agency" or resistance. As Rebecca Arnold explains, "Fashion can be used . . . to assert a type of visual and stylistic power by those who feel alienated from the main flow of political life, whether because of gender, class or ethnicity."[23] For Arnold, the "frisson of envy and desire" is at the core of modern fashion, but "the exclusion of others is as important to the couture-wearer as it is to mods or punks."[24]

At a "practical" level, to use Peter Morriss's term, the resistant agency of a subculture and the status-centered control of the upper classes both seem to be expressions of power.[25] We can see it play out in front of us on the streets of daily life—the punk asserting his identity with a green mohawk and studded leather jacket, and the uptown socialite announcing her economic authority with a couture Chanel suit. But this raises an important question about the relationship between power and fashion: does power exist primarily in the mind of individuals, regardless of their actual position in the hierarchy of capitalist society? Does the intention of the wearers to don a garment as a symbol of their own agency transform the garment into a power symbol, or must it also be collectively understood as such by the rest of society?

Valerie Steele recognizes this tension in her work on fashion and eroticism. "Sexy" garments, particularly those inspired by fetish wear are divisive. High heels, leather bondage straps, and corsets are considered by some to be symbols of objectification (stripping the wearer, usually a woman, of her authority and turning her into an object to be consumed by the male gaze). However, others consider them to be symbols of strength and power (the wearer controls her sexuality by choosing to look "sexy" rather than modest and demure). This is an issue

◀ Moschino fall 2014 runway presentation in Milan, February 20, 2014. TIZIANA FABI/AFP/Getty Images

▶ Gareth Pugh created this silver dress from slashed polyurethane. With its shiny, metallic exterior —complete with a "neck guard" choker—it mimics the look of both chainmail and a medieval suit of armor. Pugh cut the slashes by hand, giving the piece a springy drape that blends hard and soft. Gareth Pugh, dress, silver mirror finish polyurethane, spring 2011, England, The Museum at FIT, 2011.58.2, Museum purchase. Photo courtesy of Scott Tindle

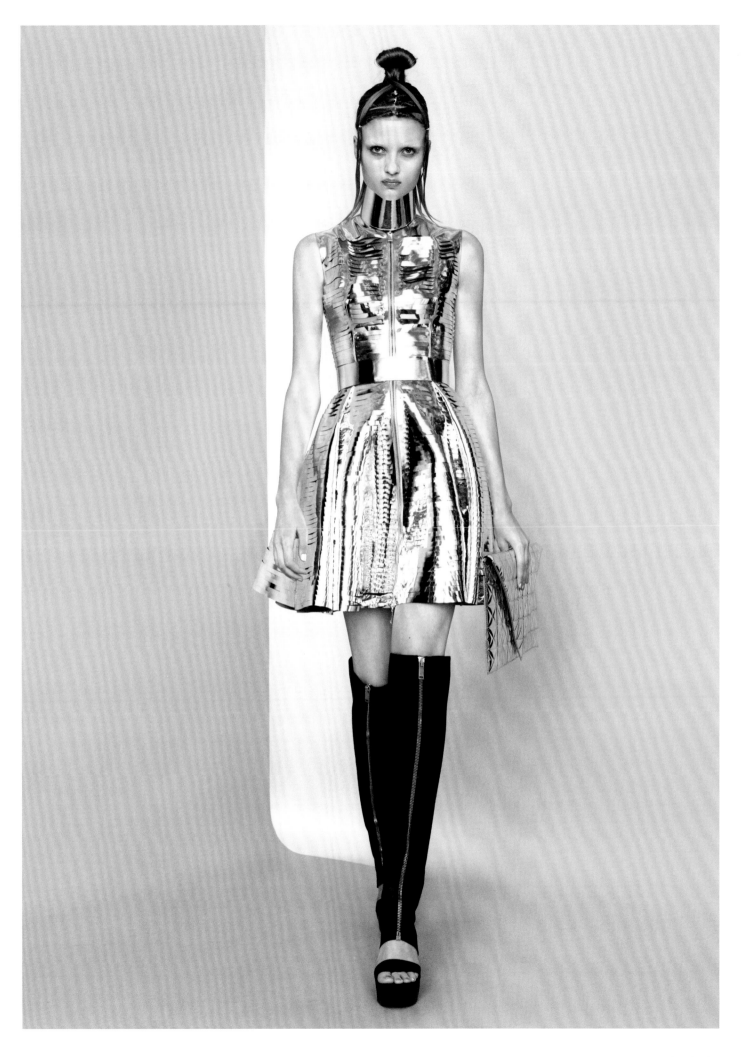

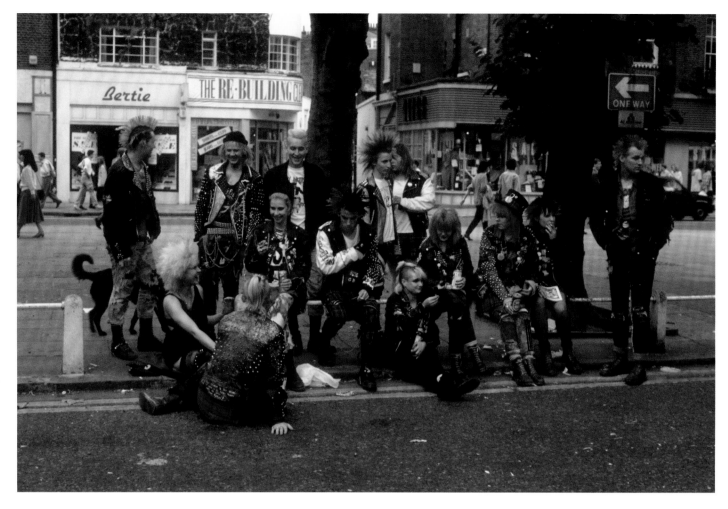

of point of view. Even if the wearer feels empowered by her leather "kinky boots," someone else might look at her and think she is being controlled by the male dominated views of heteronormative society.[26]

Scott cites the importance of the mental activity, or "imagination," of a subordinate individual in understanding the power of resistance: "They do imagine both the reversal and negation of the domination, and most important, they have acted on these values in desperation and on those rare occasions when the circumstance is allowed."[27] Of course, Scott is studying much more extreme forms of subordination than punk subculture (he is looking at slavery, apartheid, and prison systems), but his interpretation of "imagination" provides a useful model for considering the multifaceted reality of how clothing is used to express power, or the desire for power, in social life. The wearer is just as important as the viewer.

One way to reconcile dominance and agency is to simply acknowledge that society itself has had many different structures that have evolved over time. Sociologist Gilles Lipovetsky acknowledges this when he connects "the rising power of fashion in contemporary societies" to "the central, unprecedented place it occupies in democracies that have set out along the path of consumerism and mass communications."[28]

Societies change. Therefore, it follows that the meaning of power (and fashion) in social spaces evolves in tandem with social structure itself. A multi-faceted approach is necessary when considering the role fashion plays in power dynamics both historically and today.

POWER MODE

The following five chapters of this book are each devoted to a particular type of sartorial "power." They echo the sections of the accompanying exhibition. The first considers military uniforms and their transformation into fashion items. The second section explores the history of the suit. The third looks at status dressing and conspicuous consumption, while the fourth examines resistance in fashion. Finally, the fifth section analyzes objects associated with sex and sexuality.

▲ Punks hanging out on the Kings Road, London, 1983. Photo by PYMCA/UIG via Getty Images

All objects were selected from the permanent collection of The Museum at FIT. As a result, this project is by no means comprehensive. Based in New York City, The Museum at FIT's collection focuses on directional fashion from the eighteenth century to the present, with objects that predominantly originate from Europe and North America. The scope of this project is therefore similarly limited and considers notions of power from a Euro-American perspective. This is not to suggest that this is the only direction from which to approach the topic. For example, in India, *khadi* (homespun cloth) is a symbol of power, resistance, and liberation rooted in Buddhist ideology. During the independence movement, Gandhi and others encouraged people to both wear and make *khadi* as an emblem of Indian autonomy from British rule. In fact, *khadi* was such a potent power symbol that in 1947 a spinning wheel became the central figure on the newly independent Indian flag.[29]

Power Mode is a curatorial experiment. It does not purport to include every example of clothing that might be considered "powerful." Instead, it aims to combine theory with history and object analysis in order to better understand the complex nature of power in fashion, as well as the ways fashion can be key to a broader understanding of power dynamics in culture.

Men's and women's clothing are considered side-by-side, and pieces from as early as the eighteenth century are juxtaposed with looks from contemporary collections. Each section considers selected objects in terms of their form, design, history, and cultural context. Of course, garments are three-dimensional. They are lived in, not just looked at, so where possible, I try to go beyond a discussion of fashion objects as *symbols* of power to consider the impact of other senses as well, such as the haptic quality of a garment (the feeling of a fur coat against the skin, or the sensation of walking in a high heel shoe), or the auditory effect of an item (the clinking sound of a heavy gold chain), or even the olfactory nature of a garment (the smell of leather). But this is an area that warrants greater consideration.

Although the objects are drawn from a single institution's collection, the project takes a multi-disciplinary approach with contributors from across fields. Each chapter includes an object-focused essay from a renowned scholar, including Valerie Steele, Christopher Breward, Jennifer Craik, and Peter McNeil, as well as Pulitzer Prize-winning journalist Robin Givhan. These short studies provide a close analysis of a single garment and offer readers a variety of perspectives and analytical techniques. The book also includes an essay on the intersection of race, fashion, and power by Kimberly Jenkins that brings in key components of critical race theory to reframe the conversation around power dynamics in the fashion industry.

The goal of *Power Mode* is to increase awareness of the social meaning of clothing in order to help people better comprehend the objects around them. Perhaps, in a way, *Power Mode* is about giving power back to readers by providing them with tools to analyze their own clothing behaviors—tools to decode the myths that surround so many style tropes. It is only through this type of continuous analysis and questioning that we gain a better understanding of the world around us.

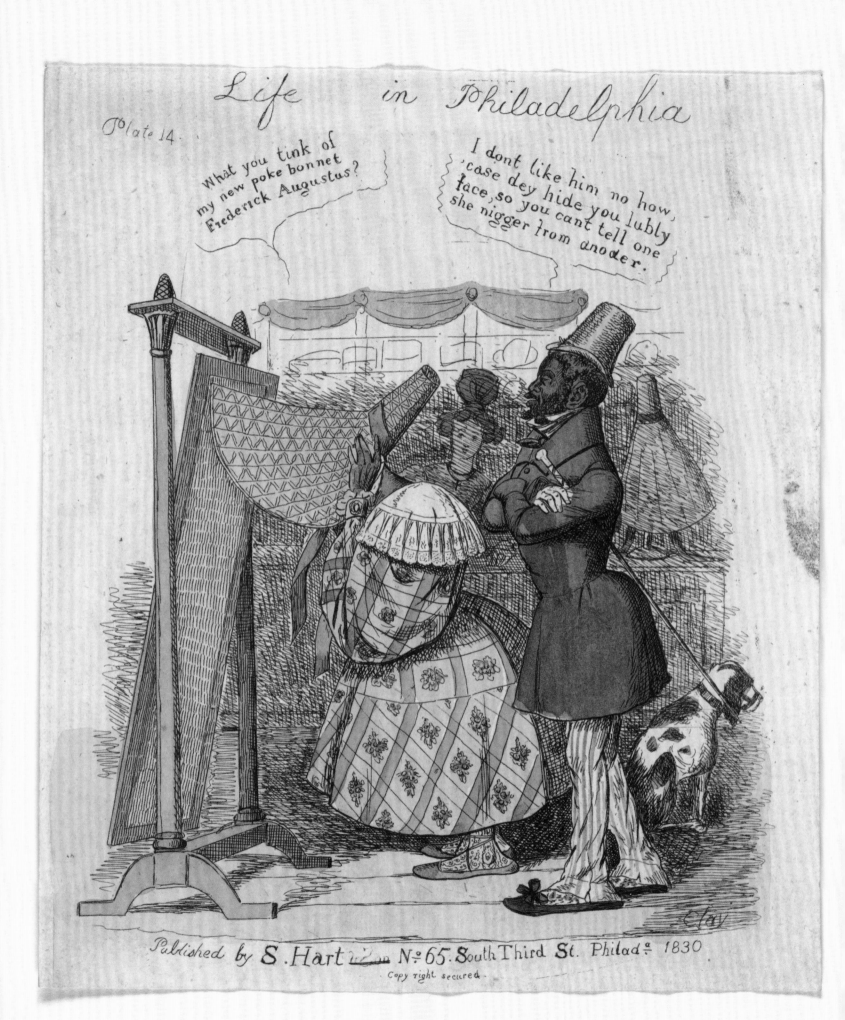

FASHION, POWER, AND THE RACIALIZED BODY

Kimberly M. Jenkins

In 2018, a number of high-profile brands, including Prada and Dolce & Gabbana, committed major public relations blunders by releasing racially-insensitive products and advertisements. Some in the community (of color) have asked, "Are they doing this on purpose? Do these fashion brands know fully well that they are mocking or triggering people of color in hopes to get attention?" People of color are all too familiar with the mental anxiety of being insulted or dehumanized, and fluent in the language and connotation that is expressed in misrepresentative images and objects in fashion.

When it comes to the intersection of fashion and race, power lays at the center. We are living in an era when information is both immediately and abundantly accessible, and our collective knowledge and understanding has expanded significantly. As a result, we are confronting the features of racism and systemic oppression ingrained in the Western canons of beauty, aesthetics, art, and fashion. Thanks to social media, those who have been minoritized and racialized are now able to question and disrupt the narratives put forth by mainstream fashion media. In addition, they are able to call out ambivalent fashion brands for the uninformed and dehumanizing *faux pas* that pervade the news cycle. This has tipped the balance of power. Those whose fashion histories have been erased or simply unresearched can reclaim their stories and work to correct misrepresentation.

As a fashion studies lecturer of color, I am interested in parsing the connotations of power and agency in racially-charged images. Key to my approach is Stuart Hall's foundational text, *Representation*. Hall, in a manner similar to John Berger, offers us tools with which we can contextualize our gaze in order to think critically about what (or whom) we are seeing when we peruse the cover of a fashion magazine, page through editorials, glance at large-scale advertisements on the street, or even scroll through fashion images on social media. For instance, how does gender mediate the appearance and perception of the subject in an image? In what ways does the social construction of race uphold the dominant narrative that saturates an image? How do geography and culture influence how an image is read? I adopt and build upon Hall's investigations of representation and situate them in the field of fashion studies as a scholarly and creative agenda that must be prioritized.

"Fashion" is most commonly understood as a capitalistic phenomenon of consumption that relies upon conceptualization, production, advertising, purchasing (or acquiring in some manner), and perhaps presenting conspicuously. This cyclical process hinges upon desire and aspiration—or at the very least upon an inclination to distinguish oneself from others. Representation can itself be considered a cyclical process within the system of fashion, as it is an ongoing practice that requires knowledge through discourse, resulting in new ways to communicate images, ideas, and things.

I propose that through a historicization of the construct of race and by tracing its path of damaging and hierarchical ideology, we can begin to cut beneath the surface of fashion's allure and problematize its desire for distinction—particularly when it comes to fashion's necessity to "other" people of color (at best) and oppress them (at worst). Specifically, it behooves those who participate in the production of mainstream fashion to be cognizant of how racialized bodies were theorized historically and why "race" continues to come into focus when fashion consumers encounter offensive or tone-deaf advertising or feel alienated from a retail brand.

Racial sensitivity is not widespread throughout the fashion system. In fashion academia, the history and theory of fashion remains Eurocentric and Western-dominated, making it increasingly difficult to bridge critical discourse with the design and business side of fashion.

◀ This illustration is one amongst many that parodied the (suggested) futile efforts of freed black Americans to understand fashionability. The black American couple gazes into the mirror while donning their ill-fitting ensembles, but little artistic effort was made to have their bodies resemble human form. The joke is played up by rendering the broken English in elegant, cursive script. William Edward Clay, "What you tink of my new poke bonnet?", in the *Life in Philadelphia* series, 1830, plate 14. Library of Congress Prints and Photographs Division, Washington, D.C.

following pages

▼ Placing these magazine covers side by side, we can see both the aesthetic and sociopolitical progress made in fifty years, a triumph of representation. In 1966, black American model Donyale Luna has her ethnic features discreetly obscured for a Civil Rights Era readership; by contrast, biracial model Adwoa Aboah sits openly for the inaugural issue of British *Vogue* in 2017 with Ghanaian-born Edward Enninful at the helm as editor-in-chief. David Bailey / *Vogue* © The Condé Nast Publications Ltd

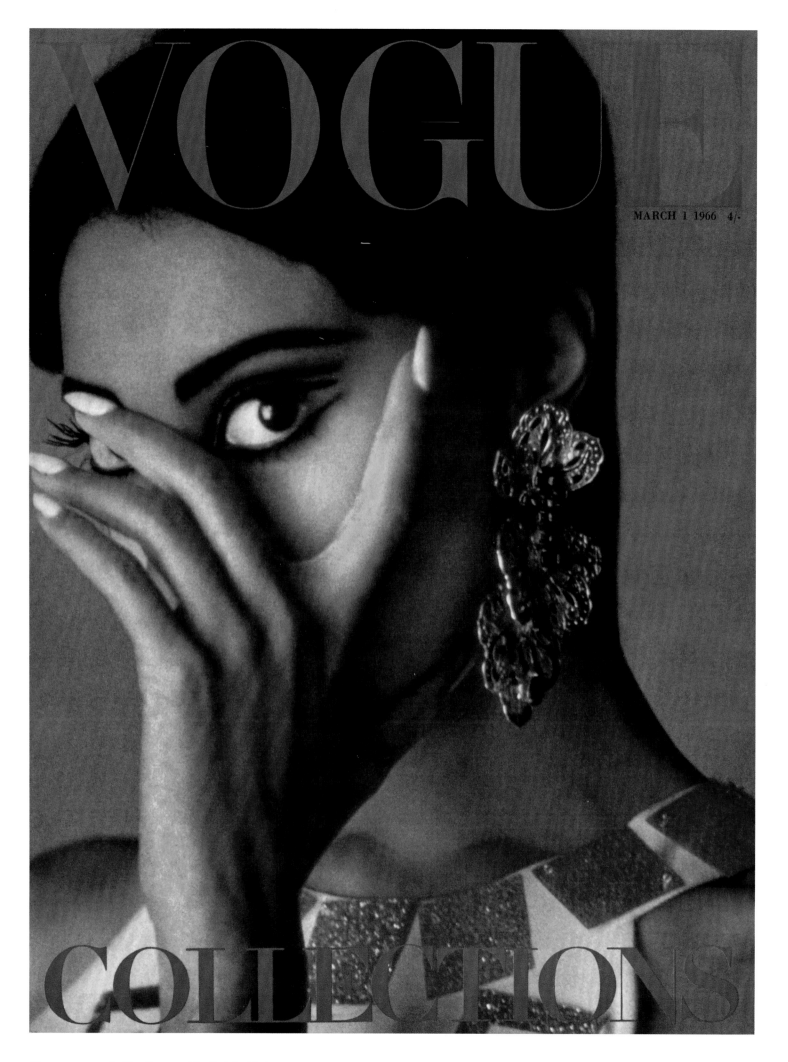

VOGUE

MARCH 1 1966 4/-

COLLECTIONS

Fashion, Power, and the Racialized Body

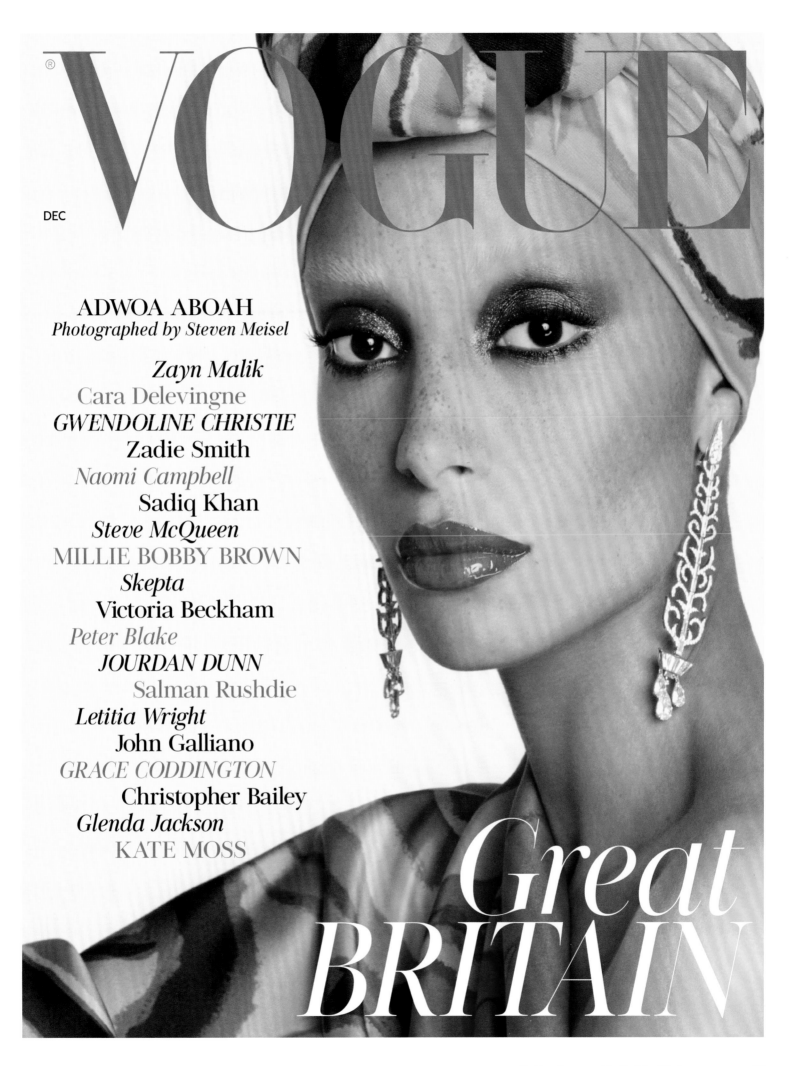

VOGUE

DEC

ADWOA ABOAH
Photographed by Steven Meisel

Zayn Malik
Cara Delevingne
GWENDOLINE CHRISTIE
Zadie Smith
Naomi Campbell
Sadiq Khan
Steve McQueen
MILLIE BOBBY BROWN
Skepta
Victoria Beckham
Peter Blake
JOURDAN DUNN
Salman Rushdie
Letitia Wright
John Galliano
GRACE CODDINGTON
Christopher Bailey
Glenda Jackson
KATE MOSS

Great
BRITAIN

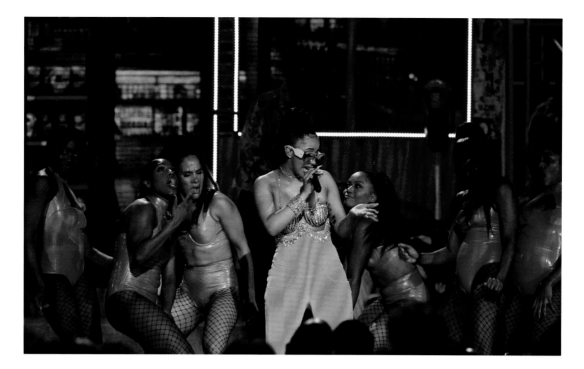

For instance, it would be useful for an editor, photographer, and stylist to be educated about the concepts in Hall's *Representation* in order to make informed and thoughtful decisions regarding how a model is positioned and presented in an image. Drawing further upon Hall, we can think about how the position of a subject and the text or language that may accompany the image can exalt or disgrace the subject we see. When it comes to considering the legacy of race and how it unconsciously shapes the way we process an image, the body, clothes, cosmetics, and setting are all susceptible to stereotypic tropes and possible missteps of inclusion.

Whether the subject is a model whose role is to promote "fashion" or everyday individuals who have "fashioned" their identity, I incorporate the scholarship of Joanne Entwistle and Elizabeth Wilson to help make sense of how the construct of race and its theoretical companion, the racialized body, can influence dress, fashion, and fashionability. Entwistle and Wilson call our attention to the ways in which clothing (and we can also consider hair) is an intermediary between the self and society, as they situate the psychological terminology "embodiment" and "embodied cognition" within fashion studies. This crucial nexus—the garment or a fashioned look—is where the racialized body must manage various forms of labor that extend beyond the research and assemblage work that the non-racialized body needn't prioritize.

Generally speaking, fashion consumers regularly make numerous decisions about what to wear by conducting research on clothing and cosmetics to ensure that their look aligns with their identity. They also perform the labor of managing their appearance to communicate distinction or affirm their social position. Those decisions are, in many ways, influenced by cultural norms and dominant social narratives, along with select information disseminated by the fashion media. We can layer onto this consideration what Stuart Hall writes about in *Representation*, that (fashion) images or objects in and of themselves denote what they appear to be in form, but when accompanied by language and sociocultural context, the image or object can connote something loaded with emotional and political meaning.

What does dress and appearance mean for individuals whose lived experience has been colored by legacies of racism and systemic oppression? Or, to use a racially-charged example from the United States: when is a hoodie simply a hoodie? When it's on the body of Mark Zuckerberg or when worn by Trayvon Martin? It goes without saying that a hoodie becomes politically charged once it is worn by a racialized body.

Depending upon one's lived experience, society adds to our personal understanding of what the clothes on our backs or the styling of our hair *mean* to us, which illustrates how clothing can become "embodied" even as it facilitates the discourse between cloth and society on and through

◀ Rapper Cardi B performing at the 2017 BET Hip Hop Award. Cardi B's unapologetic persona and love of fashion is on full display, showcasing how garments can become both "embodied" and "customizing agents" on the racialized body–an activation among self, dress, and social perceptions.
Photo by WENN Rights Ltd / Alamy Stock Photo

the body. Ultimately, the cognitive process becomes relevant to how we dress and present ourselves, as the onus is on the racialized body—the labor, or "extra work" as scholar Minh-Ha Pham calls it, suddenly extends beyond the pleasures of shopping and self-fashioning to veer into the cognitive, physical, and emotional territory of repression and self-defense. It is at this juncture where clothing and hairstyling and overall fashioning of the self must navigate and attempt to subvert strains of systemic oppression and hegemony.

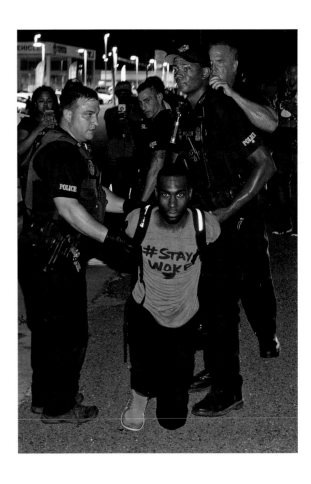

The racialized body—if it navigates any social or cultural environment for which "race" is known and operates—is hypervisible and susceptible to a nuanced and critical gaze that may challenge it on the battlefield for power and distinction. Here, "fashion," which by definition smacks of elitism and upward mobility, can create either an added social obstacle or provide leverage for substantive power. In this case, clothing and styling can be seen as what scholar Gwendolyn O'Neal observes as a "customizing agent," where the "idiosyncratic expression" of the (racialized) wearer can inject meaning and guide self-determination, resulting in a kind of self-fashioning that revels in agency.

Since at least the eighteenth century, it has been documented that minoritized and racialized groups of individuals have encountered obstacles—even to the extent of legal mandates and sumptuary laws—to their enjoyment of fashionability. The power associated with fashioning the body on one's own terms, distinguishing oneself from others, and acquiring fashionable objects of potent value, signifies the insatiable desire for freedom as expressed by the labor of styling and the exercise of consumption.

Styling is a significant labor practice in terms of power, as there is an interplay of "asset" acquisition and protection between minoritized, racialized wearers and those wearers who benefit from hegemony. Adopting an economic paradigm and referencing what scholar Anita Franklin has written about in terms of the critical dress choices that black women make, style as a labor practice involves the acquisition and protection of assets, with assets referring to meaningful dress assemblage, hairstyling, and possibly cosmetics (in other words, the "look"). For a person of color whose body has been racialized by society, features or even the sum of their look can signify a "liability," at risk of becoming the thoughtless or uninformed raw material for an ambivalent designer's runway collection, or the subject of employment discrimination, or of being viewed as a self-expressive display that disturbs "respectability politics."

When the politics of appearance are at play, the racialized wearer works out the fashioning of identity in spite of racism and systemic oppression, subverting oppression and resisting attempts to control or regulate how they appear. It is through the labor of styling the body that agency is seized and that affirmation of one's identity and sense of place is anchored, enlisting the extra work of defending one's precious assemblage and protecting the fashioned body from appropriation, misrepresentation, and dehumanization.

The fashion system is a site for us to reckon with this phenomenon, which points to the pleasure and power enjoyed from assembling an identity constructed by styling and consuming. However, it is also necessary that through a discourse that engages knowledge and empathy, the fashion system reconstructs a canon of history and theory that broadens the narratives of what we wear and why, and works toward thoughtful and inclusive representation to reveal the full spectrum of what fashion and power embody.

▶ Activist Deray McKesson was photographed and filmed by bystanders during his arrest by police officers in Baton Rouge, Louisiana, on July 10, 2016. An officer could be heard shouting, "You with them loud shoes, I see you in the road. If I get close to you, you're going to jail." The profiling, targeting, and arrest of Deray McKesson was notable, as the key identifier was his brightly colored shoes, affirming that the performance of fashionability is not only stigmatized and mocked in certain circumstances, but it can be judged as unvirtuous and lacking taste when the racialized body engages with it warranting unjust treatment. Photo by AP Photo / Max Mecherer

CHAPTER 1 DRESSED FOR BATTLE

Emma McClendon

The modern military uniform as we recognize it typically centers around a tailored jacket punctuated by distinctive colors, braiding, trimming, and brass buttons. This style originated in France with the *justacorps*[1] (knee-length wool coat) in the seventeenth century and reached its fullest expression during the Napoleonic era of the early nineteenth century, which Jennifer Craik once described as "the crowning glory of military uniforms."[2] This is not to suggest that militaries did not have distinctive forms of dress prior to this period. Indeed, soldiers of the Roman Empire wore coordinated tunics and armor plating, and the notion of armor has long fascinated fashion designers. However, the French combined modern tailoring with refined surface embellishments to establish a strict visual vocabulary for military attire that was based as much in "glamour" as it was in uniformity and utility.[3] This is the duality and paradox of military dress—it is designed to both blend in and stand out, and to be seen and to be used. In Stefano Tonchi's words, "From the outset, the military uniform has had a dual nature: theater and function."[4] It is this "dual nature" that has helped propel uniform garments beyond the confines of military institutions into everyday wardrobes and high fashion collections. But the attraction of the military uniform is also fundamentally rooted in the uniform's status as a symbol of power.

The French approach to military uniforms affected not only design but also distribution. Versions of the new tailored uniforms were eventually worn throughout the full ranks of the armed forces, not only by the officer class. This visually transformed the entire armed forces into a symbol of political strength. As Craik describes:

> . . . the development of military dress in modern Europe developed alongside the emergence of civil society, so military functions (attack and defense) were only one role of the military. They also symbolized the character (and health) of the political regime and of the authoritative command of the state.[5]

Thus the solider, no matter his rank, became a walking extension of the state's power. As Foucault put it, from the seventeenth century "the soldier was someone who could be recognized from afar . . . his body was the blazon of his strength and valour."[6] The tailoring and the materials used in uniforms were taken from fashionable dress on purpose—to endow members of the military (and the state, by extension) with glamour and refinement. If a state could dress its soldiers well, it communicated a sense of financial security, in addition to military strength. The meticulously controlled and maintained uniformed body of the military (both individual and collective) was now seen as a direct reflection of the control, stability, and authority of the government.

Intricate rules were codified to govern how to wear and care for uniforms in order to ensure an individual soldier would correctly embody the state.

◀ Models in military inspired looks as seen in *Vogue Japan*, June 2015. Photo by Emma Summerton / Trunk Archive

▶ General uniform from the Napoleonic era in Carle Vernet, *La Grande Armée de 1812*, folio 1, print. Image courtesy of Fashion Institute of Technology | SUNY, FIT Library Unit of Special Collections and College Archives

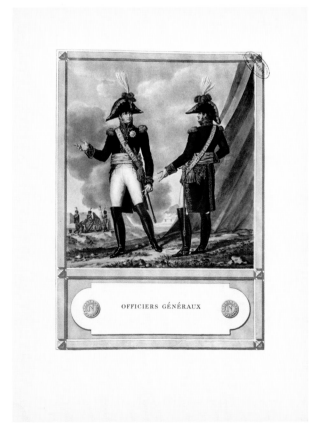

OFFICIERS GÉNÉRAUX

Eventually, these rules gave rise to the development of different categories of uniforms for specific functions (for example, dress uniforms for formal and official occasions, service uniforms for daily operations, combat uniforms for the field, etc.).

At a basic level, military uniforms are also designed to communicate to civilians that, as Lorenzo Greco says, the wearer has access to and "control of powerful weapons."[7] Thus, in addition to being a proxy for the state's power, the military uniform also conveys the lethal power of the individual wearing it. The wearer is trained in combat, weaponry, and might be carrying a weapon on his person. He could kill you. It is power as domination in the most instinctive sense—the power over another to harm or kill.

Of course, uniforms are also designed to communicate power dynamics within the military itself. While a civilian might loosely identify different military uniforms by the cut, color, shiny buttons, and epaulettes, a member of the armed forces would be able to decipher the code of symbols on a uniform more fully. The military world is a highly hierarchical environment based on a system of authority and subordination. A unit's ability to function rests in its ability to follow orders quickly and efficiently, and a set of orders could have life and death implications. To follow (or give) orders, a solider needs to be able to recognize his own position within the hierarchy of authority and be confident that his position is recognizable to the others around him. Soldiers need to clearly *see* who is in charge.

The distinctive patches, stripes, and shapes on a military jacket, as well as particular colors, surface embellishments, and accessories each convey a different piece of information, such as which branch of the armed services the wearer belongs to (army, navy, air force), the wearer's rank, the wearer's unit, and so on, positioning the wearer within the military chain of command. Greco describes this sign-heavy approach to design as "semiotically explicit."[8] As he explains, this is necessary because the military's "hierarchical structure is full of situations of potential interpersonal conflict," and "it is absolutely necessary to rely on an unquestioned mutual trust based on a strong sentiment of consensus."[9] There needs to be trust in the structure and in the order of command, and this structure needs to be understood and communicated quickly and easily through signs on uniforms rather than words. As such, uniforms are "minutely regulated"[10] from the moment a new recruit enters a training facility.

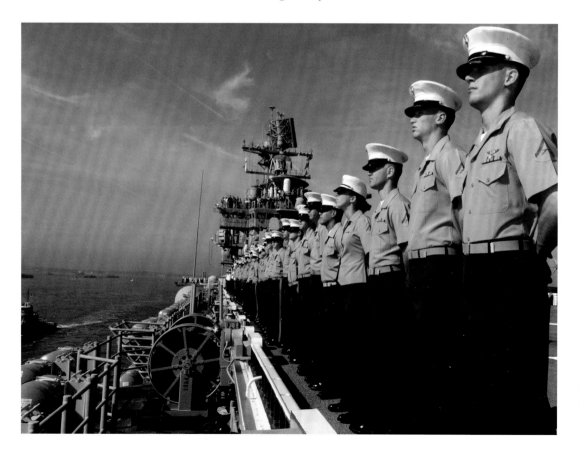

◀ US Marines aboard the USS Iwo Jima during Fleet Week in New York, May 26, 2010. Photo by PJF Military Collection / Alamy Stock Photo

The way a new recruit wears and cares for his uniform is closely monitored throughout training, complete with uniform-specific forms of reward and punishment to instill correct behaviors. For example, at the Royal Military Academy Sandhurst in England, new recruits must fold their uniforms in specific ways and place them within drawers in certain positions prior to room inspections. Each part of the day (physical training, classroom work, etc.) has its own specific uniform. If a recruit is dressed incorrectly, or if the uniform's presentation does not meet the standard dress code (if a shirt is wrinkled, a boot smudged, or a crease mis-ironed), the recruit must wear the uniform again that evening while standing at attention until the officer on duty comes by to inspect him—but the officer can come anytime between 8:00 and 10:00 pm.

These practices—including haircut, posture, and pose—are what Greco describes as "semiotics of the body." The body (like the mind) is conditioned through repeated behaviors. The soldier's trained body was Foucault's prime example of the "discipline" inherent in power over both an individual and population body. As he describes, "the soldier has become something that can be made; out of a formless clay, an inapt body, the machine required can be constructed."[11] A civilian body is honed, or "constructed," into a soldier's body over time. The uniform is on the front line of this transformation. It is "an apparatus," to use Craik's words, "to instill discipline by training the body and mind in specified ways."[12] Thus the uniform represents the wearer's domination and control over his own body in addition to his power as a weapon-wielding proxy for the state.

Historically, uniform garments were far better quality than a soldier's civilian clothes. As a result, soldiers would continue to wear parts of their uniforms long after their service ended. This practice gave rise to some of the most common military crossovers into civilian wardrobes, including khaki pants, "Ike" jackets, peacoats, and "bomber" jackets. As Tonchi observed, "Soldiers in every war have come back from the front with new experiences and terrifying tales, but also with military garments that silently became a part of everyday dress."[13]

Unlike military uniforms, their fashion adaptations are not designed with Foucauldian "discipline" in mind. They are about drawing attention to the individual rather than blending into a larger group. The military's complex semiotic code is lost. Instead, the most recognizable elements of uniforms—the colors, textiles, buttons, etc.—become visual shorthand for the power, strength, and authority of the military. It is the power of association. As Craik explains, "the superficial 'look' of uniforms as markers of group belonging, authority, discipline . . . shape[s] the unconscious resonances of and responses to uniforms."[14] By sheathing yourself in an army-green "Ike" jacket, you cover yourself in a recognizable symbol of power that makes you stand out in a crowd of other civilians. But pairing the jacket with jeans or a tulle skirt, for example, signals it as a fashion item rather than a uniform.

This subversion of the uniform's group-focused design endows military fashion with a rebellious edge, further diverging from Foucault's disciplined and dominated body. These fashion garments are deconstructed and reconstructed. They are paired with slinky dresses and high heels. They are imbued with sex. They are also vehicles for branding. A company logo replaces the state's seal. It is a paradoxical union, but one that has pervaded the industry. At its core, the military takeover of the fashionable wardrobe is steeped in a craving for power.

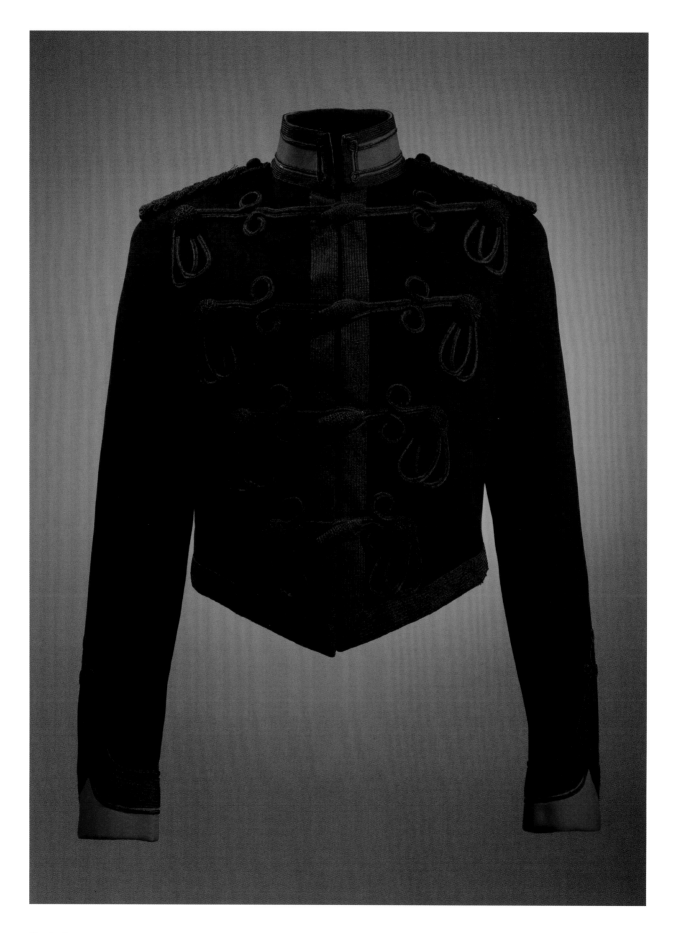

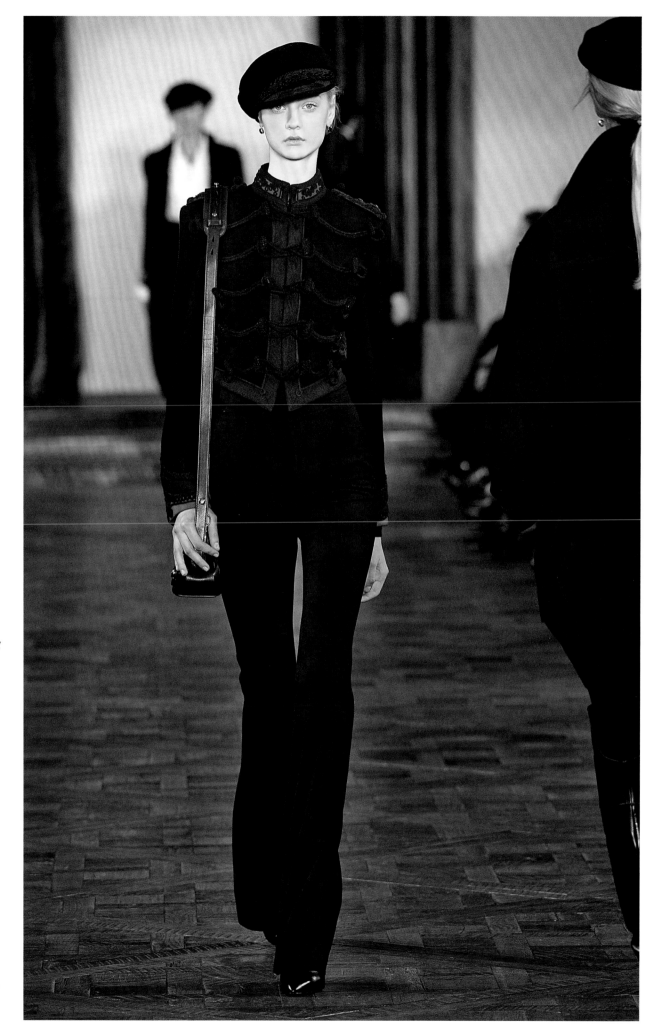

◀ Man's King's Royal Rifle Corps "mess dress" jacket, green wool, red wool, black braid, c. 1900, England, The Museum at FIT, 73.6.351, Gift of Adele Simpson

The elaborate braiding and soutache on this jacket signify a particular regiment in the British Armed Forces. The heavy threads originally served as a form of protection against blades in hand-to-hand combat. As combat uniforms became less ostentatious during the twentieth century, such ornamentation was relegated to formal uniform jackets (termed "mess dress"), still worn by British officers today.

▶ Ralph Lauren, ensemble, wool and synthetic blend, fall 2013, USA, The Museum at FIT, 2016.5.1, Gift of the Ralph Lauren Corporation

Military braiding and soutache began appearing on women's clothing during the nineteenth century, particularly in outerwear. The use of such details has endured in high fashion. Here, Ralph Lauren reinvented the King's Royal Rifle Corps jacket for his women's fall 2013 collection.

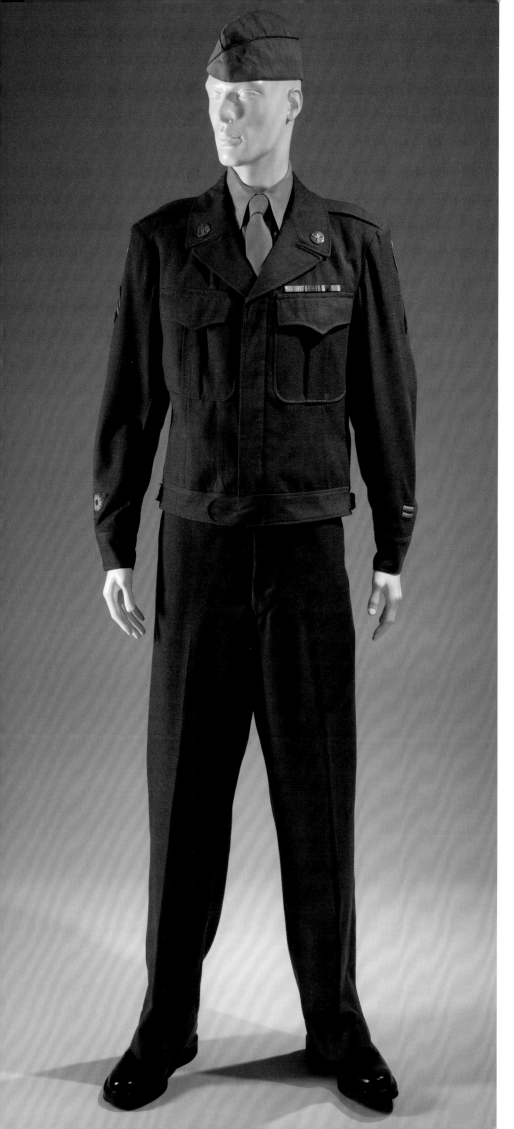

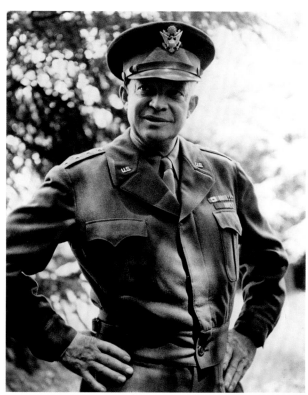

◀ Man's WWII U.S. Army Air Corps uniform, green wool, cotton, metal, 1945, USA, The Museum at FIT, 90.171.5, Gift of Mary Jane Pool

The "Ike," or "Eisenhower," jacket was added to regulation U.S. Army uniforms during World War II. Officially called the M-1944 jacket, it was designed to be worn on its own or under a larger field jacket. It owes its name to General Dwight D. Eisenhower (nicknamed "Ike"), who helped approve the style, and afterward was rarely photographed wearing anything else.

▲ General Dwight D. Eisenhower during World War II. Photo by World History Archive / Alamy Stock Photo

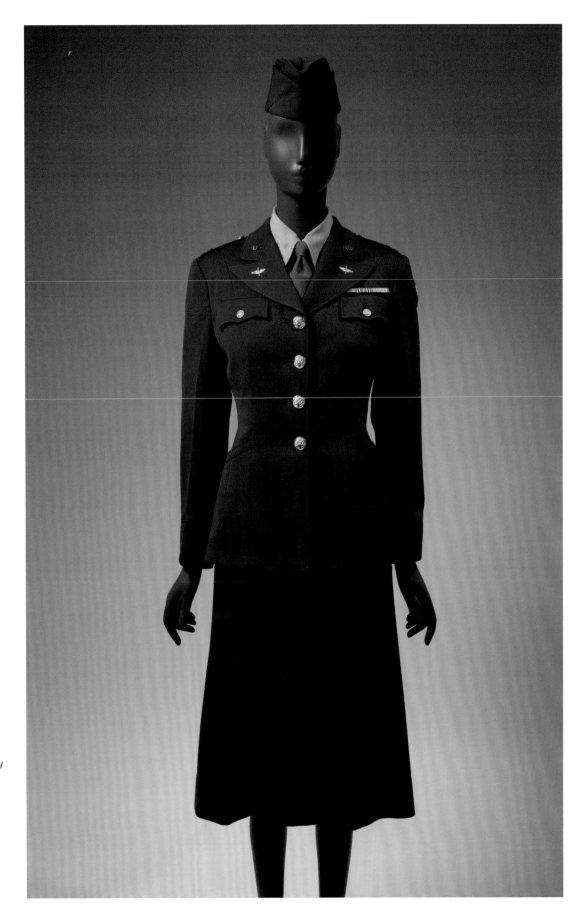

▶ WWII WACs uniform, green wool and metal, 1943, USA, The Museum at FIT, 85.74.6, Gift of Dorothy Warren

This uniform was issued to members of the Women's Army Corps (or WACs) during World War II. It is made from the same olive drab as the men's uniforms, but the jacket is paired with a skirt. Many formal uniforms still include skirts for female members, exposing the gender tension in modern military uniforms.

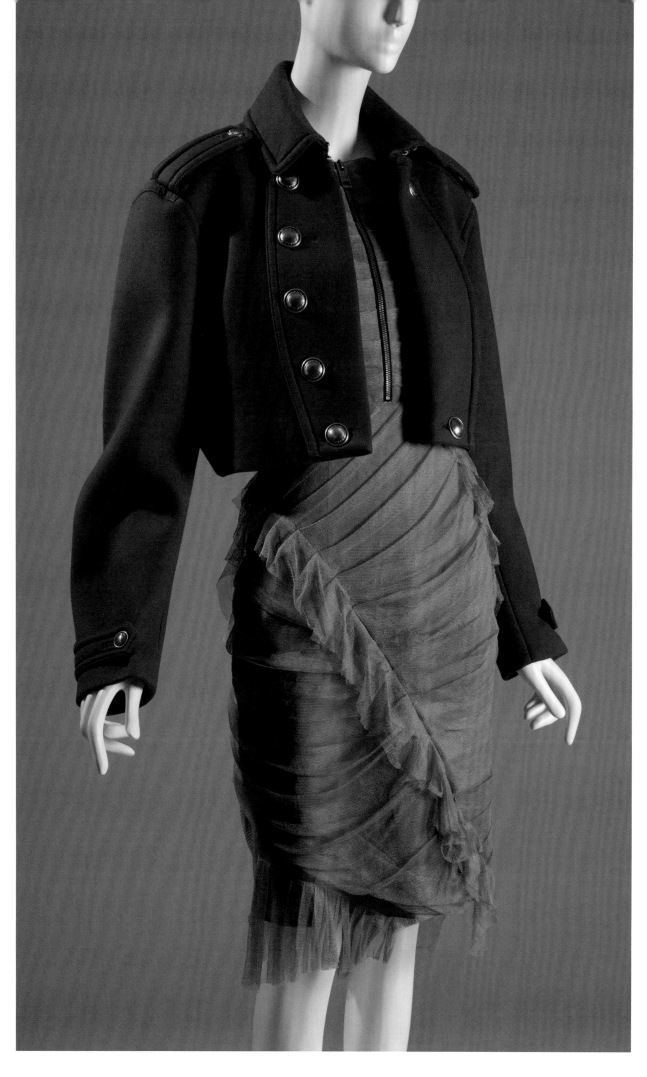

◄ Burberry, ensemble, green net, green wool, black leather, fall 2010, England, The Museum at FIT, 2010.62.1, Gift of Burberry

Burberry famously supplied canvas raincoats (dubbed "trench" coats) for British troops during World War I. Christopher Bailey frequently referenced the brand's military legacy in his ready-to-wear collections. Here he juxtaposes a cropped olive drab jacket with a ruched dress of army green netting.

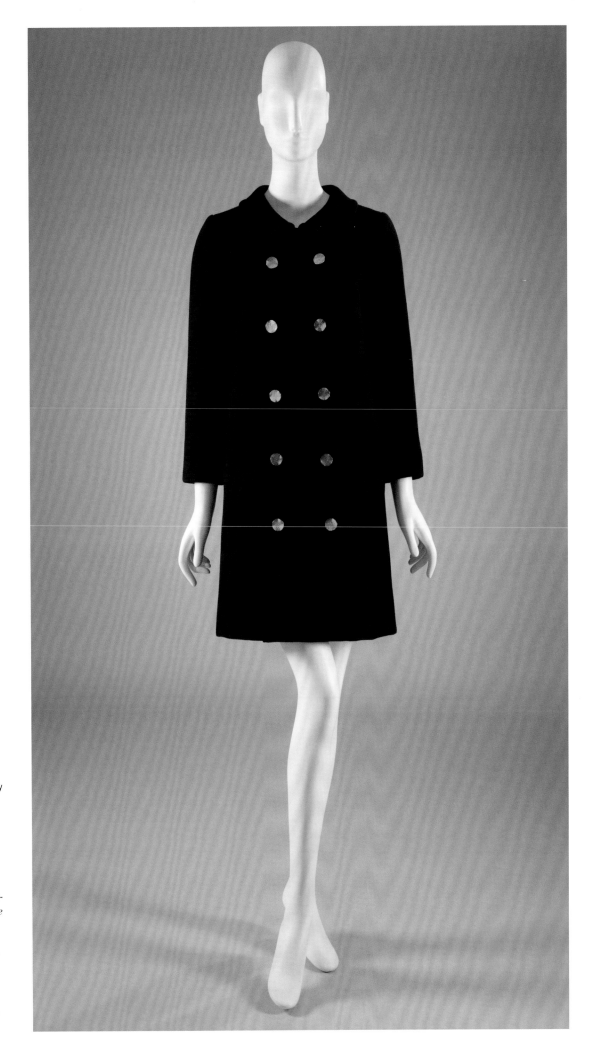

▶ Yves Saint Laurent, coat, navy wool and metal, 1966, France, The Museum at FIT, 78.85.3, Gift of Doris Strakosch

Yves Saint Laurent began experimenting with military elements during the mid-1960s. The dark blue, double-breasted coat quickly became one of his signature styles. Originally inspired by the naval "peacoat" worn by sailors to keep warm, the recognizable dark blue coat punctuated by gold-tone buttons has become a fixture of fashionable wardrobes.

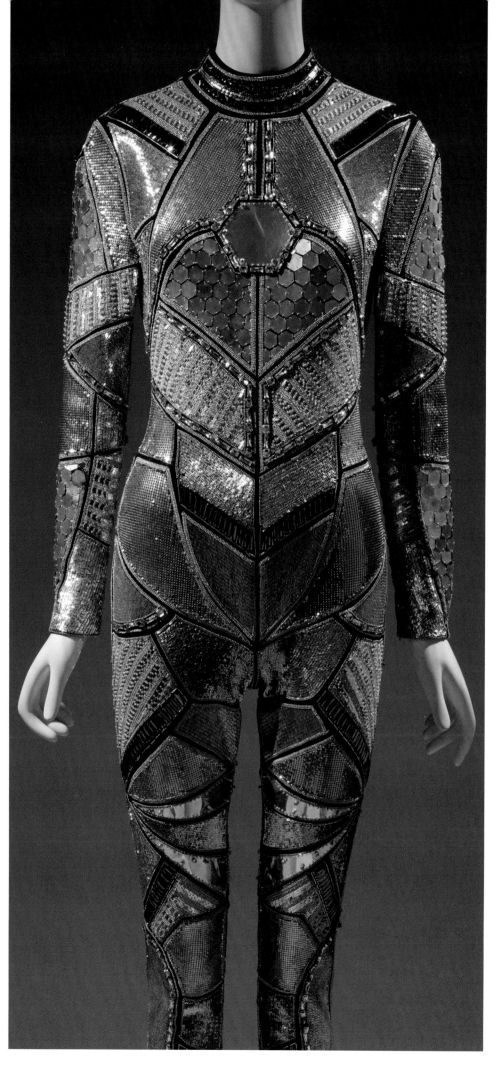

◄ Philipp Plein, jumpsuit, spandex, glass, plastic, 2016, Germany, The Museum at FIT, 2017.50.2, Gift of Julie Macklowe

This Philipp Plein jumpsuit effectively recalls plates of armor, but on closer inspection each geometric panel is delicately constructed from beads, rhinestones, and paillettes. The "power" of armor has long fascinated designers as a source of both defensive protection and offensive strength. Yet more futuristic than medieval, this look combines the bionic woman and the white knight.

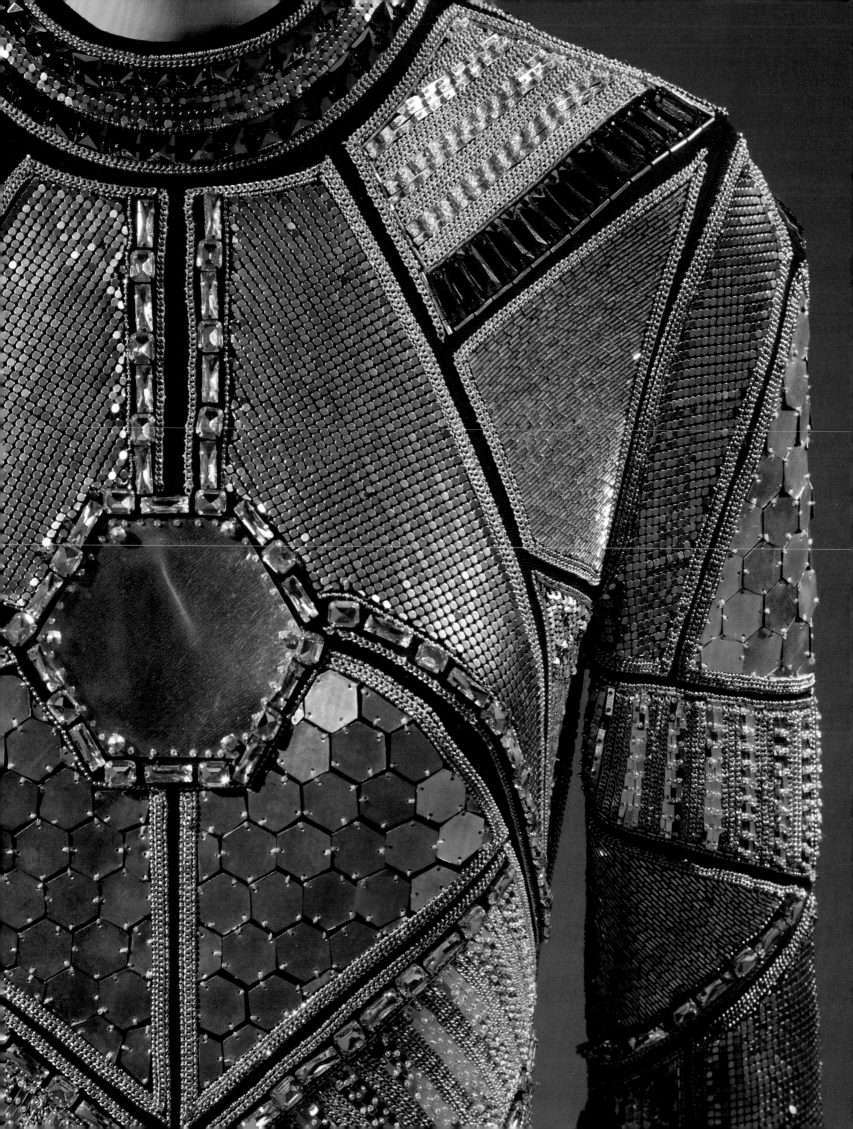

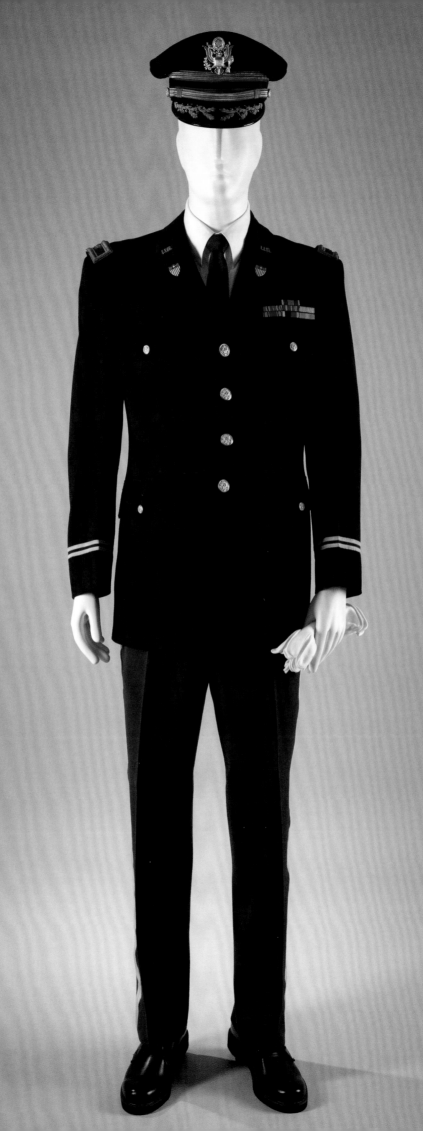

A LIEUTENANT COLONEL'S DRESS BLUES

Jennifer Craik

Military uniforms convey occupation, identity, discipline, and authority. Indeed, people say that they feel different and act differently upon donning a uniform. Likewise, the behavior of those who interact with a uniformed person can be shaped by the very presence of the uniform. This makes uniforms potent weapons in the *demonstration* of power relations, social regulation, and maintenance of authority.

Why are uniforms so pervasive as a sartorial symbol of power relations, roles, status, social hierarchy, and responsibilities?

The example of Lieutenant Colonel U.S. Army "dress blue" uniform, c. 1950, epitomizes the relationship between power and fashion and wider cultural implications of uniforms. Military uniforms signal membership in a fighting group as well as rank, role, and hierarchy within the group. A military uniform is also a visible and immediate way to distinguish friendly troops from enemies. The use of symbols such as stripes, braid, patriotic insignia, gold buttons, epaulettes, and large functional pockets reinforces the cohesion within the group while visibly demonstrating discipline, reliability, constancy, and authority that commands the respect and obedience of civilians and others.

This particular uniform emerged when the U.S. tradition of using blue in military uniforms (beginning during the eighteenth century, with the Revolutionary War) combined with a project to modernize combat uniforms after the Second World War. While uniforms for active duty increasingly focused on function and utility (including camouflage, protective devices, and wearability), dress uniforms were worn for ceremonies and official occasions only in the postwar era and required elements of symbolism to convey the role, status, and authority of personnel.

The choice of a fitted, single-breasted, dark navy, long line jacket with comfortable blue trousers fits within trends in postwar men's fashion. This classic combination of tailored jacket and trousers was transformed into a statement about power by a number of decorative features. These included the use of gold buttons, plus decorative epaulettes, gold stripes above the cuffs, golden tuxedo stripes down the outer legs, and badges displaying U.S. national insignia (tricolor stars and stripes, the bald eagle) that reinforced the stature of the military in civil society. The power conveyed by the dress uniform cemented the status of officers within and outside the military institution.

These messages are amplified by details such as the four deep-pleated, button-down pouch pockets with bellow gussets highlighted by gold button closures, as well as the name tag and patches indicating military rank, service, and decorations.

To top it off, the uniform features a striking peaked cap with a flared crown, called a combination cap. Adopted by the U.S. Army in 1846, the cap band incorporates a red branch-of-service stripe between two gold stripes. The crown displays a gold badge in the shape of the bald eagle, the insignia of the U.S. coat of arms. The black plastic visor is embroidered with a delicate pattern of oak leaves (nicknamed "scrambled eggs"). A chin strap is also attached.

◀ Lieutenant Colonel U.S. Army "dress blue" uniform, blue wool, white cotton, metal, c. 1950, USA, The Museum at FIT, 95.102.2, Gift of the Heirs of Teresa Lambert Ireland

The "dress blue" uniform is complemented by a pair of white cotton gloves which were worn for ceremonial purposes only and, according to the attached *Washing Instructions*, required careful laundering to retain their shape, fit, and pure white color. This refined fashion statement completes the image of power for this field officer.

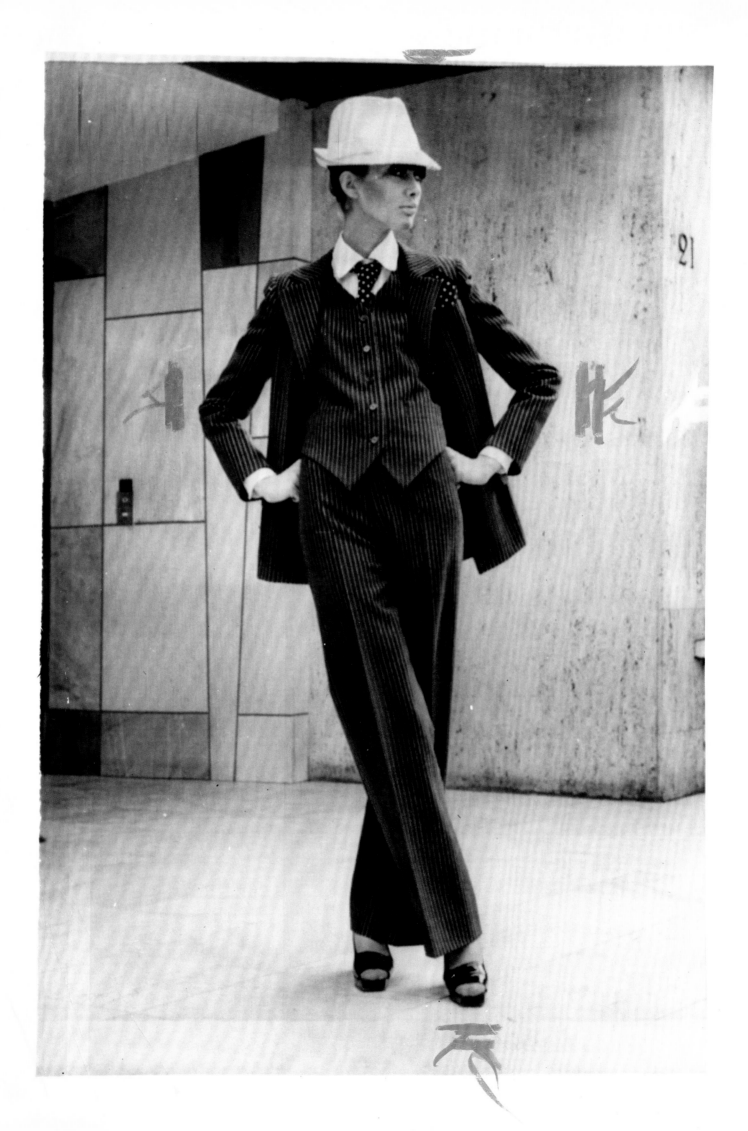

CHAPTER 2 SUITED UP

Emma McClendon

The sharply tailored suit is perhaps the most conventional example of "power dressing." Indeed, the term "power dressing" is typically used to describe big-shouldered suits worn by upwardly-mobile businesswomen during the 1980s.

The suit began as menswear, of course. Some historians trace the exact birth date of the suit as far back as the fourteenth century, while others begin their chronologies in the seventeenth, when King Charles II of England decided to wear a coordinated vest underneath his regular court attire. However, all agree it was during the nineteenth century that the "somber" suit rose to its dominant position as the *de facto* uniform of "civilized" male society. "Somber" and "civilized"—as well as "modern," "minimalist," "sober," and "serious"—are among the adjectives most often used to describe the typical suit. These words position the suit in stark opposition to fancy, frivolous, and showy "fashion." It is a serious outfit for serious men—men in command of strong intellect, financial means, and a sense of propriety. In other words, men in a dominant social position. Men with power.

This is not the same power as the power to kill or the power of the state embodied in the military uniform. Instead, it is the power to influence the actions of others within a professional or social setting, connecting back to Robert Dahl's definition of power as an individual's ability to get another person to do something they "would not otherwise do."[1] Think of a corporate boss in a meeting doling out projects, or even the popular notion that wearing a suit will help you get better treatment in day-to-day life. In an episode of the popular television show *Bob's Burgers*, the usually-apron-clad protagonist Bob borrows a suit for a court appearance about a parking ticket and immediately begins to be treated differently. The judge looks him up and down and decides to dismiss the ticket, jokingly telling Bob, "Maybe next time use the valet." Later, a woman on the street refers to him as a "nice gentleman," and the *maître d'* at a fancy restaurant seats him right away despite the hour-long wait for everyone else.[2] This is obviously an exaggerated, comedic portrayal, but it builds on the cultural perception of the suit as indicative of its wearer's power and importance.

But what garments are we actually referring to when we say the word "suit"? For Anne Hollander, it is a "pants-jacket-shirt-and-tie costume."[3] However, Christopher Breward describes it as "a long-sleeved, buttoned jacket with lapels and pockets, a sleeveless waistcoat or vest worn underneath the jacket (if three-piece) and long trousers,"[4] with no mention of Hollander's shirt or tie. This is a conundrum of the suit—while seemingly ubiquitous, there is actually such variety in the design of suits that it can make them tricky to define. Here, I will take "suit" to mean a coordinated ensemble of tailored jacket and pants (or skirt) made from the same fabric. What is worn underneath can vary (tie or no tie, shirt or no shirt, vest or no vest). According to this definition, coordination and tailoring are the central design principles, and the jacket is the most important part of the ensemble.

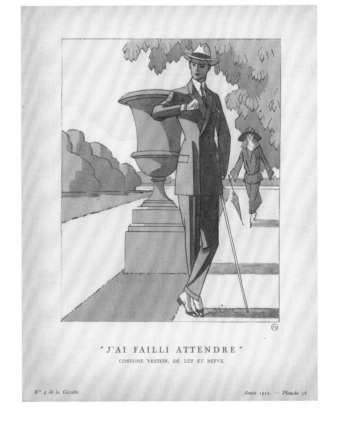

"J'AI FAILLI ATTENDRE"
COSTUME VESTON, DE LUF ET BEFVE

N° 4 de la Gazette *Année 1922. — Planche 26*

◀ Photograph of a model in a Yves Saint Laurent three-piece suit, February 25, 1967. Nina Hyde Collection. Image courtesy of Fashion Institute of Technology | SUNY, FIT Library Unit of Special Collections and College Archives

▶ René Préjélan, *Gazette du bon ton*, no. 4, 1922, pochoir print. Image courtesy of Fashion Institute of Technology | SUNY, FIT Library Unit of Special Collections and College Archives

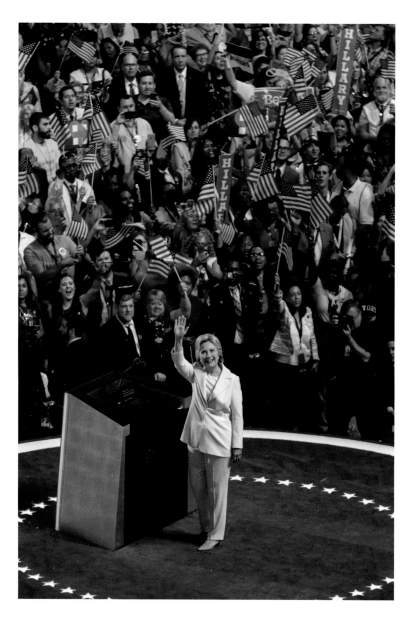

The classic form of the modern suit jacket with its strong, angular shoulders and plunging neckline offset by a neatly creased lapel mimics the lines of the idealized male body—articulated, agile, virile, muscular. As Hollander once put it, "all modern suits have been cut to suggest a male body that tapers from broad shoulders and a muscular chest, has a flat stomach and small waist, lean flanks, and long legs."[5] Key here is the "discreet padding in the upper chest and shoulders"[6] that creates a sharp silhouette over the body of the wearer. "Thus the male figure was recut and the ideal man recast,"[7] to use Hollander's words. Like Foucault's soldier molded from clay through training, the unwieldy natural body is honed into an "ideal man" by the suit.

Within common histories of the suit, the nineteenth century is referred to as the era of the "Great Masculine Renunciation"—a term coined by John Carl Flügel to describe the shift in elite male dress from ostentatious clothing made from colorful brocades and elaborate embroideries to a more monochromatic wardrobe of black, gray, and navy wool suits. According to this view, women continued to wear technicolored finery, so the "somber" suit served to visually differentiate between sexes. Flügel linked the "renunciation" to the political shift toward democracy and away from aristocratic authority. Hollander, however, also connects the mass adoption of the "sober," hyper-masculine suit to shifts in religious practices (away from the decadence of Catholicism toward the restraint of Protestantism) and the growing influence of military uniformity that had been building in Europe over the previous two centuries.[8] As she explains, "War and religious fundamentalism both tend to dramatize the difference between the sexes."[9]

Of course, the suit is no longer strictly worn by men or those in dominant social positions. During the nineteenth century, suits became available at every level of the market, from high-end custom versions to much cheaper, ready-made ones. The suit was now a staple of everyday clothing and no longer necessarily signified its wearer's authority. This murkiness still exists today. As Hollander observes, "Heads of state wear suits at summit meetings, male job applicants wear them to interviews, and men accused of rape and murder wear them in court to help their chances of acquittal."[10]

The suit is a symbol. In certain settings it is worn to convey power and influence, but it has also become a symbol of blending in or, perhaps more accurately, "fitting in." As menswear expert G. Bruce Boyer explains, "If you accept a job with a large law firm and the other lawyers wear suits, the sartorial ground has been laid for you, and those who rock the boat must be aware that other passengers will try to throw them overboard."[11] For both the first-year associate and the accused murderer on trial, the suit is a symbol of his submission to the power of cultural

◀ Hillary Clinton at the Democratic National Convention, July 28, 2016. Photo by Don Mennig / Alamy Stock Photo

rules of a corporate setting or society more broadly. Thus, the power dynamics of the suit are multifaceted. Similar to the military uniform, it can convey both authority and subordination—individual importance and group belonging—depending on the setting and the wearer.

For example, a male prisoner uniform from 1913 features a coordinated gray jacket and pants. Although crude and made from denim, the uniform's construction is based in tailoring. It is a suit, but not in the way we are used to discussing suits. It was distributed to incarcerated individuals and was designed to be a marker of their subordinate position. The wearer of the suit blends into a group, and the suit symbolizes his lack of power. He is under the authority of the guards. However, the use of a suit as prison uniform could also relate to the idea of the prison as an opportunity for rehabilitation. As Foucault points out, the existence of the modern prison is "based on its role . . . as an apparatus for transforming individuals."[12] The suit as uniform might thus have been conceived as a "tool" to help "re-civilize" prisoners, in much the same way a soldier's uniform serves as a tool in his training.

For women, too, donning a suit can be about both blending in and asserting power, individually or collectively. We saw the latter in the bloc of female representatives who wore white suits to the 2019 State of the Union, referencing the white suit Hillary Clinton wore in 2016 as she became the first woman to accept the presidential nomination of a major party, as well as the white suits of American and British suffragettes who fought for women's right to vote a century ago. However, the suffragettes' white suit itself carried a dual meaning of authority and subordination. It was a power statement in both its bright white color and its appropriation of male sartorial authority. But, as a suit, it was rooted in a male definition of political society. It literally sheathed and confined the suffragette body in a symbol of *male* civility.

The complex power dynamics inherent in the suit's history have made it a fertile playground—or "vessel," to use Breward's term—for fashion designers' creativity. Yves Saint Laurent famously adapted archetypes of menswear (complete with pants) for female clients during the late 1960s and 1970s—a move that has been interpreted as a feminist power statement. A decade later, Giorgio Armani became renowned for deconstructing the hard lines and inner structure of the classic man's suit to "free" the male body. Today, the suit has returned to the runways and wardrobes of fashionable men and women alike in response to the current socio-political climate. Grace Wales Bonner and Thom Browne create suits that challenge tailoring's stereotypically "masculine" aesthetics, both tightening and shortening traditional lines, while womenswear designers like Marc Jacobs make moves in the opposite direction, increasingly obscuring the female body under swaths of cloth and dramatic proportions. It is the resonance of the suit as a symbol of power that attracts designers to its form—a resonance that shows no signs of waning.

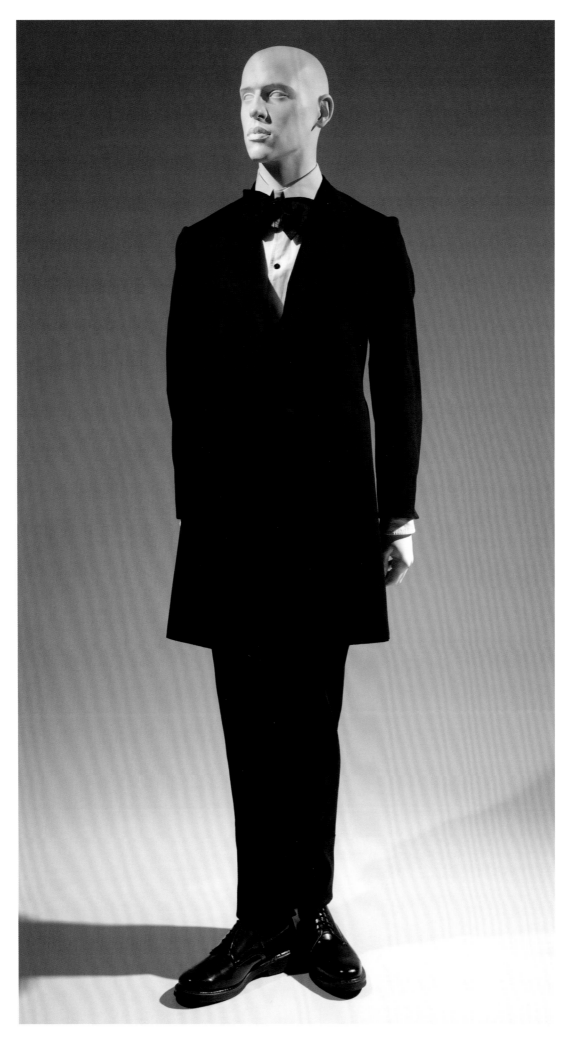

◀ Man's suit, black wool, c. 1860, USA, The Museum at FIT, P90.2.4, Museum purchase

This monochromatic black suit is emblematic of the "somber" and "restrained" dressing that has come to define nineteenth-century menswear. Although the jacket is longer than styles are today, the general silhouette, color, material, and tailoring seen in this suit can be found in contemporary equivalents, attesting to the style's longevity.

▶ Suit, gray and blue linen, 1896, USA, The Museum at FIT, 84.26.1, Museum purchase

This woman's suit draws inspiration from menswear in its color, pointed lapel, and tailored jacket. However, its puffed sleeves and skirt width place it firmly within the trends of women's fashion. As women were increasingly involved in both leisure activities and different segments of the work force at the end of the nineteenth century, they took sartorial cues from menswear, particularly the suit—the emblem of civil society.

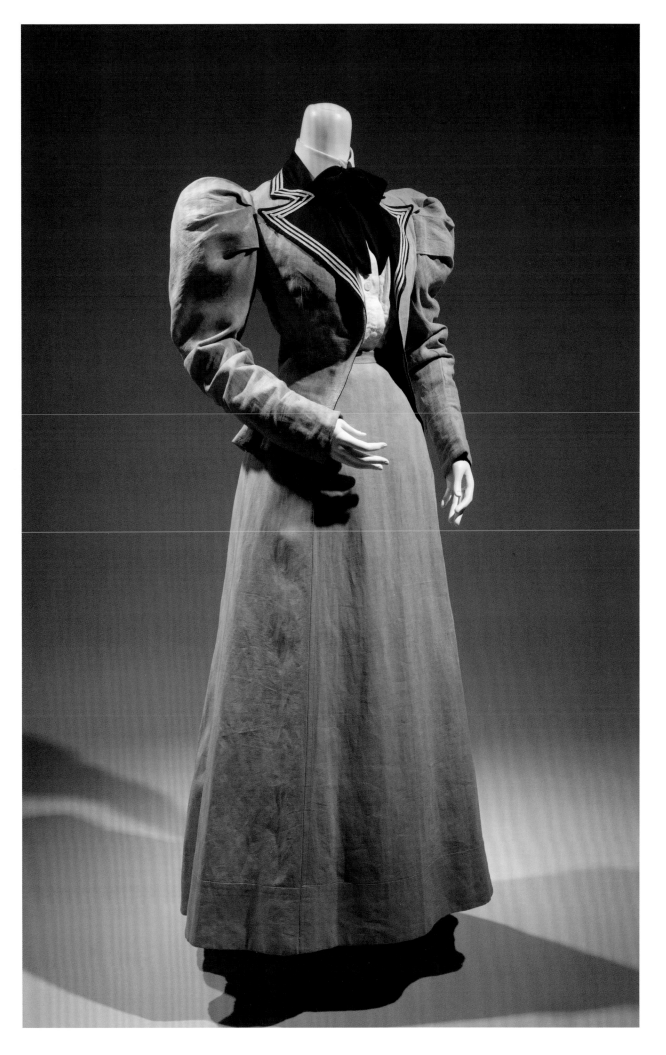

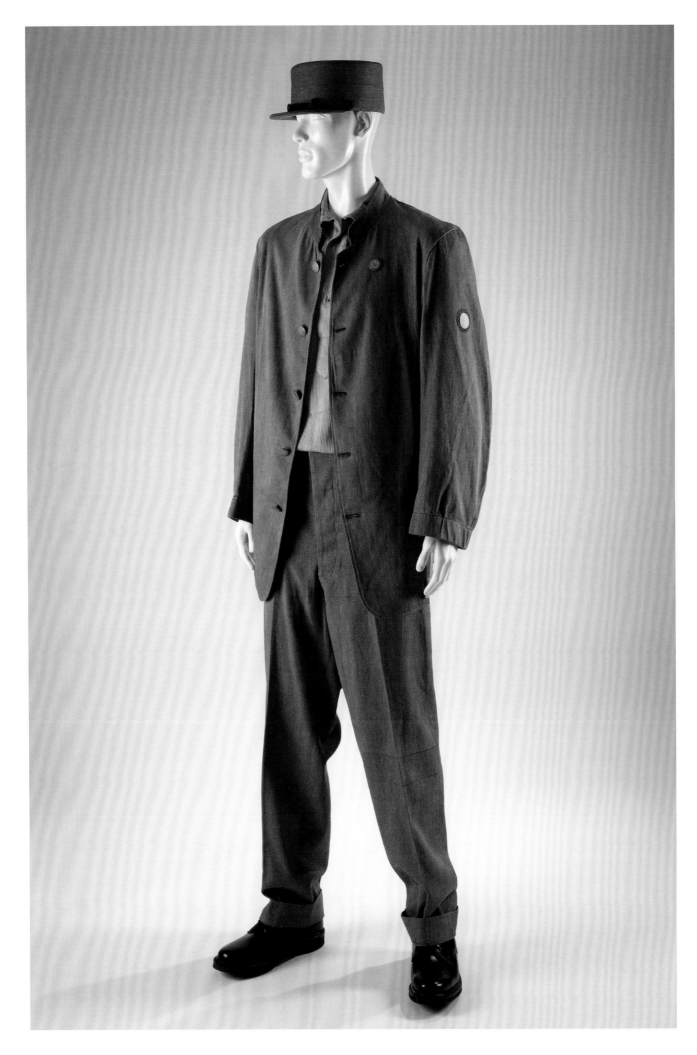

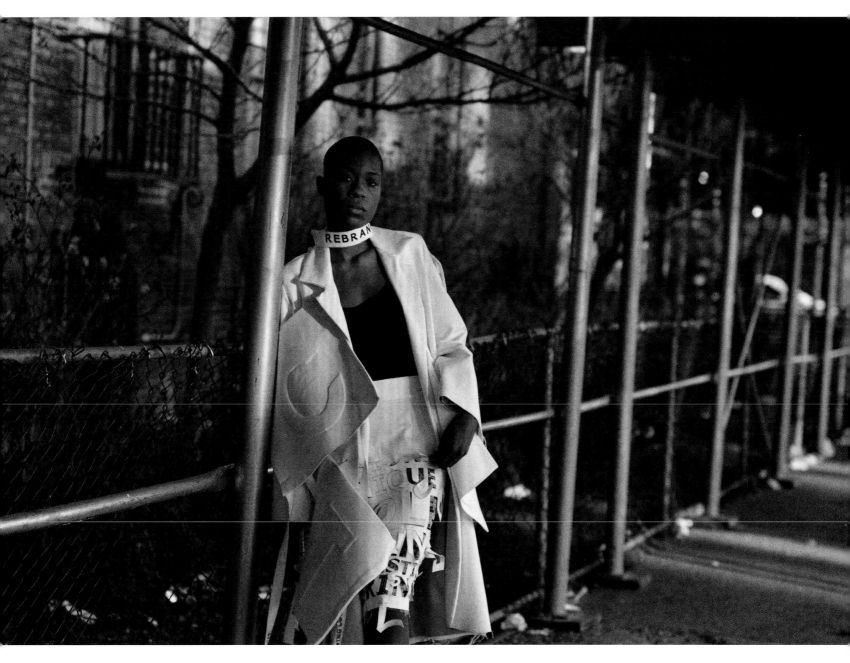

◀ Auburn State Prison uniform, gray denim and linen, 1913, USA, The Museum at FIT, 93.26.1, Gift of Lithgow Osborne

The hat, jacket, and pants of this prisoner uniform were made from gray denim. This type of coordinated ensemble, or "suit," was standard throughout the American correctional system for the first half of the twentieth century. As a symbol of an inmate's subordinate status, it proves the relativity of the suit's "power."

▲ Joy Marie Douglas, "Rebranded" suit, white wool, 2017, USA, The Museum at FIT, 2019.18.1, Gift of Joy Marie Douglas

Joy Marie Douglas designed this suit as part of her "Rebranded" project—an ongoing collaboration with previously incarcerated individuals to create looks that reclaim pejorative words like "convict." Here, Douglas deconstructs and reconstructs the classic "power" suit, infusing these words in its design. The result allows wearers to "rebrand" themselves through fashion.

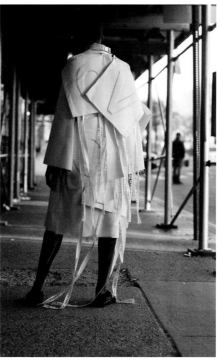

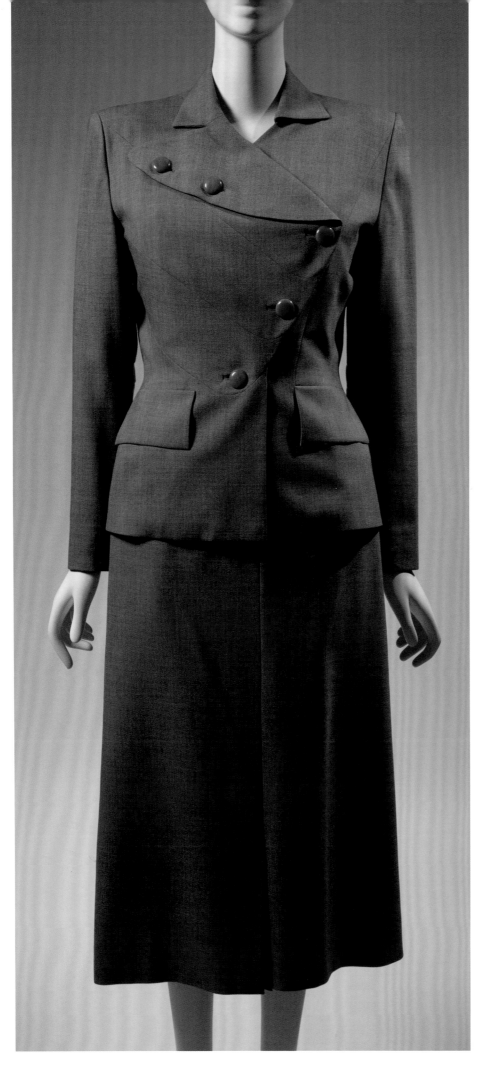

◀ Adrian, suit, gray wool, 1948, USA, The Museum at FIT, 2010.1.52, Gift of anonymous donor

Adrian was renowned for his angular suits. While today the term "power dressing" is often associated with the shoulder-padded suits of the 1980s, the dominant style of the 1940s was also a "masculine" proportioned suit. Broad shouldered jackets paired with narrow-hipped skirts minimized the "feminine" curves of the wearer.

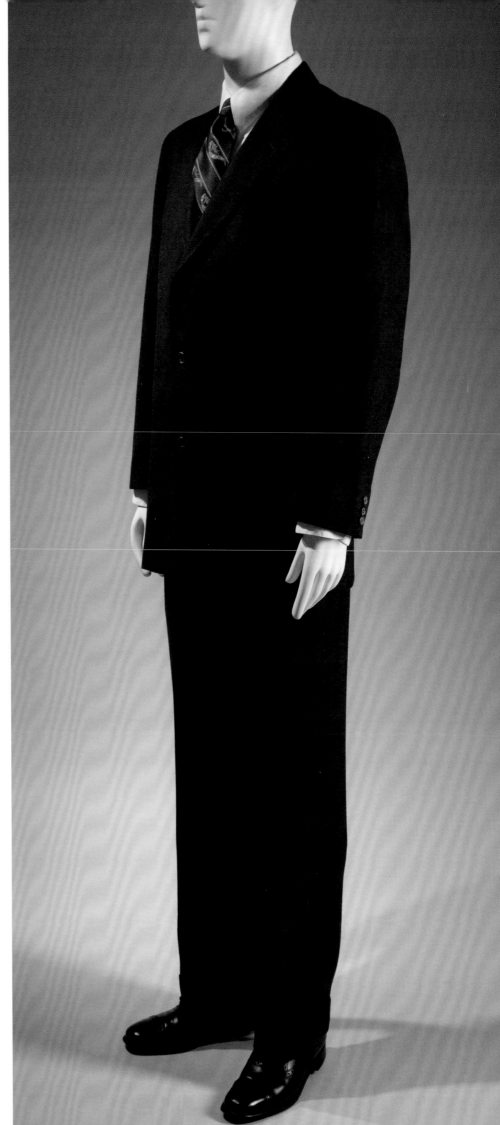

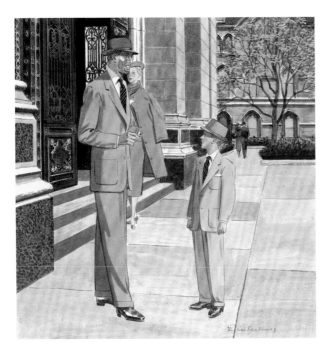

▶ J. Press, man's suit, gray wool, 1975, USA, The Museum at FIT, 2012.37.1, Museum purchase

The gray flannel suit became the unofficial uniform of the white-collar American businessman during the mid-twentieth century. The suit's ubiquity inspired the title of Sloan Wilson's 1955 book The Man in the Gray Flannel Suit, *in which the suit is a symbol of the middle class suburban experience in a postwar culture focused on upward mobility. The suit was worn to give the wearer increased social power, but it was also a sign of conformity.*

▲ Allen Saalburg, France Neady study collection, original illustration for *Esquire*, 1952 (published April 1953), watercolor on paper. Image courtesy of Fashion Institute of Technology | SUNY, FIT Library Unit of Special Collections and College Archives

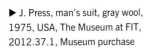

◄ Yves Saint Laurent, suit, off-white wool with gray pinstripes, 1979, France, The Museum at FIT, 86.101.17, Gift of Lauren Bacall

Yves Saint Laurent unveiled his first woman's pantsuit in 1966. Dubbed "le smoking," it was literally a man's tuxedo tailored for a woman's body. Although considered shocking in the late 1960s, the pantsuit became a staple of the fashionable woman's wardrobe during the 1970s. Along with "le smoking," the double-breasted pinstripe "gangster" suit was another signature Saint Laurent style.

▶ Giorgio Armani, man's suit, brown and blue-gray wool, 1982, Italy, The Museum at FIT, 85.58.7, Gift of Mr. Jay Cocks

The loose woven wool of this suit adds greater movement and drape to the classic silhouette. Giorgio Armani developed his signature "deconstructed" suits during the 1980s, stripping the jacket of its traditional padding and rigid materials. Armani's name soon became synonymous with luxury tailoring, making his suits a power statement for 1980s Wall Street tycoons.

▶ Thierry Mugler, suit, black wool and faux leather, 1991, France, The Museum at FIT, 2016.47.2, Gift of Anna Cosentino

Thierry Mugler is one of the designers synonymous with the "power dressing" look of the 1980s. His bold-shouldered suits often incorporated futuristic elements. Here, Mugler has trimmed the classic black suiting material with leather, adding reptilian fins to the cuffs and asymmetrical lapel, and a sci-fi applique to the chest.

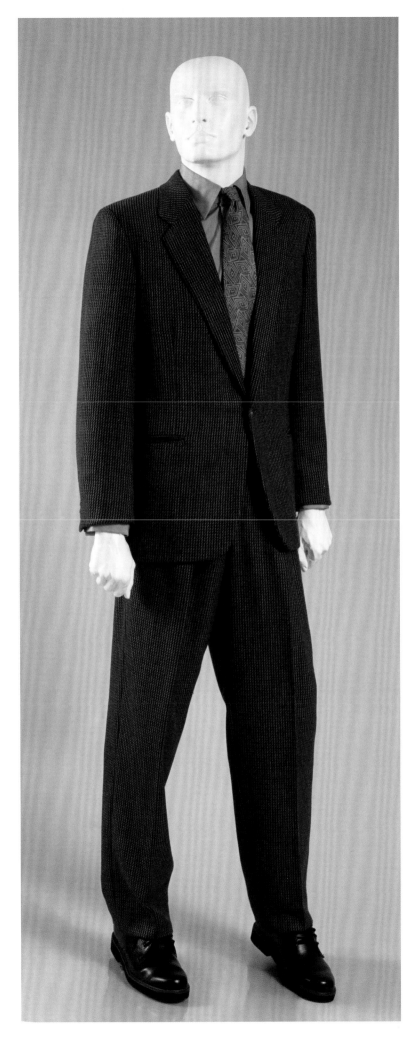

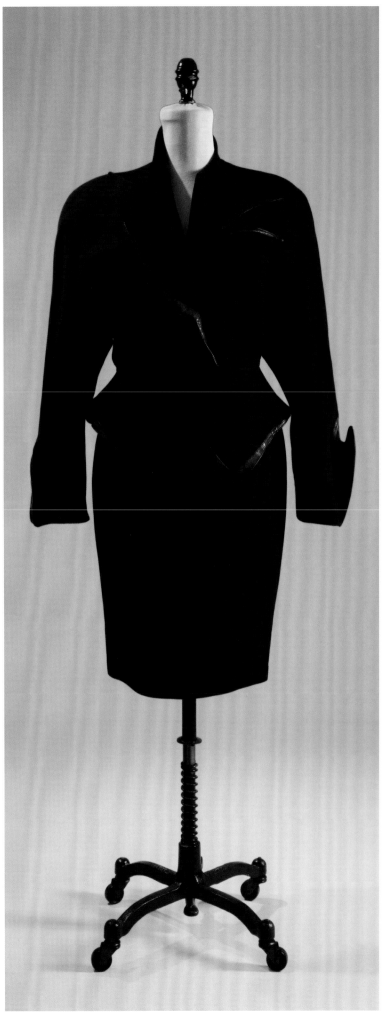

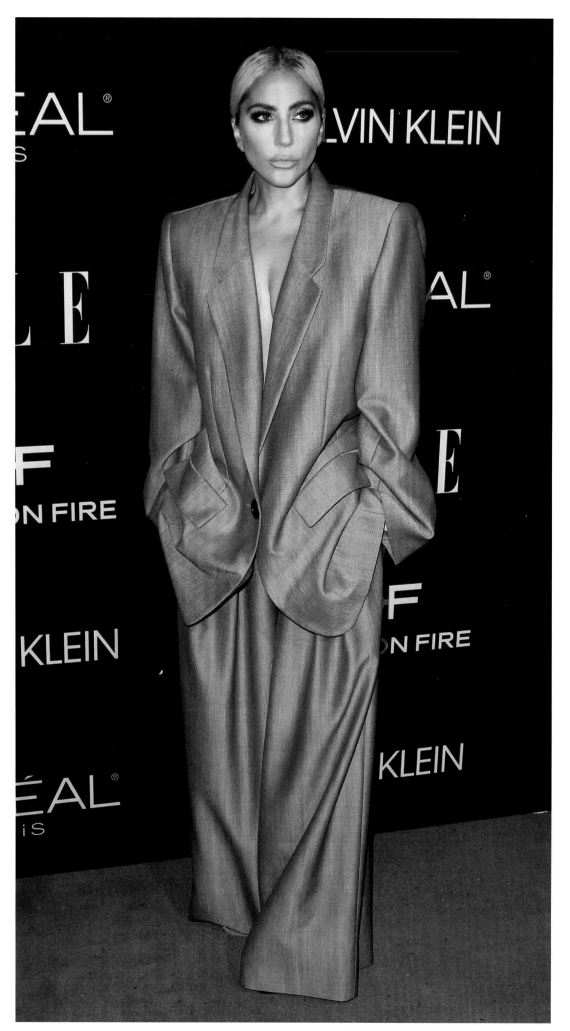

◄ Marc Jacobs, suit, gray wool, spring 2019, USA, The Museum at FIT, 2019.25.1, Museum purchase

Lady Gaga wore an oversized Marc Jacobs suit to ELLE Women in Hollywood event in 2018. The suit's design exaggerates the "masculine" proportions of the classic suit. Gaga related her decision to wear the suit to her experience as a survivor of sexual assault, saying "I decided today I wanted to take the power back. Today I wear the pants."[1]

► Thom Browne, man's suit
and bag, gray wool, cotton,
leather, silver, 2018, USA,
The Museum at FIT, 2018.5.1,
Gift of Thom Browne

*Thom Browne is best known
for his "shrunken" gray suits
that play with proportions.
By pairing a tight fitting jacket
with shorts, Browne challenges
the "masculinity" of the suit
and infuses it with the look of
adolescent school uniforms.
The inclusion of an oversized
handbag further bends gender
lines. LeBron James wore
a version of this suit during
the 2018 NBA playoffs.*

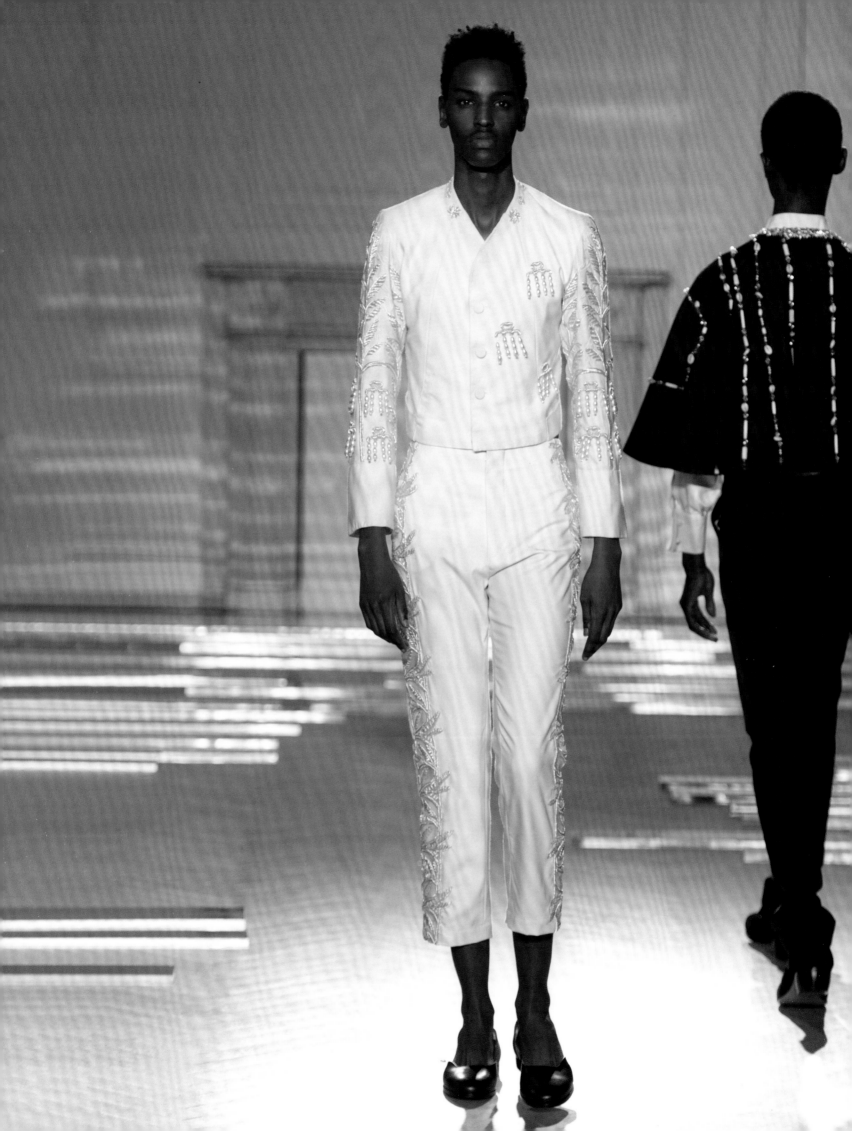

GRACE WALES BONNER

Christopher Breward

Since her 2014 graduation from Central Saint Martins School of Art and Design, London, Grace Wales Bonner has pioneered a nuanced practice grounded in a profound understanding of the literary, cultural, visual, and social heritage of the post-colonial subject. Shifting deftly between Africa, Europe, India, the Caribbean, New York, and her native London, her points of reference encompass the creativity of the Harlem Renaissance, the laments of slave-era spirituals, the fashion-activism of modern and contemporary African politics, and the street argot of 1980s styling. All of this is translated into menswear collections of a profound elegance and intelligence. In an era when truth and beauty are contested and disavowed, and minority and diasporic identities put under unprecedented pressure, Wales Bonner's work perfectly echoes her given name. It offers grace in troubled times.

The evening suit in creamy-white wool, its narrow cropped-leg pants and collarless jacket embellished with silver bullion wire embroidery of vine leaves, fringe metal, pearl, and rhinestones is a perfect illustration of her signature style. Suggestive of Spanish bullfight attire, early nineteenth-century military ceremonial dress designed for the Sotadic Zone, and high-church ecclesiastical vestment (not unlike the baroque imagination employed in Gertrude Stein, Virgil Thomson, and Florine Stettheimer's ground-breaking all-black opera *Four Saints in Three Acts* of 1934), the ensemble accentuates long limbs and a boyish waist, evoking in the words of Wales Bonner's text for the spring 2017 collection (mystically named after the prophet Ezekiel) "the mix of cultural flavors that arrive in the Caribbean . . . A journey through the nightlife, fetish in glints of silver and studs . . . Majestic sweat."[1]

Since this, her first solo show, Wales Bonner has continued not only to pioneer an intelligent sartorial vision for men that articulates the productive tensions between hard and soft power that underpin a twenty-first-century rejection of old-style hegemonic masculinity for more fluid versions, but to push fashion practice in new and challenging directions. Her collaborations with creative institutions, curators, and artists (the Serpentine Gallery, the Victoria and Albert Museum, the Josef Albers Foundation, Hans Ulrich Obrist, the musician Sampha, Eric N. Mack, Michael-John Harper, Ben Okri) are typical of an approach that seeks to re-write fashion's narratives to reveal new magic. In describing her creative practice, Grace Wales Bonner promises a mystical transformation:

> When someone has a strong presence you know what their vibe is, and you see that in intellectuals . . . they're serious people. There's conviction, and continuity over time. There's tailoring but it's integrated with something a bit more intimate. There's something about the way they use clothes, the way they put things together, that no one else would think of . . . I was creating this idea in my mind of the shamanic artist who collects things . . . He will go to a market and pick out a particular scarf or wear something more feminine. They're super comfortable with themselves, they gather things and they're quite nomadic. There's a delicacy and intimacy, wearing these things that are quite magical.[2]

◀ Grace Wales Bonner, man's evening suit, white wool, metal, pearls, rhinestones, spring 2017, England, The Museum at FIT, 2016.86.1, Museum purchase. Image courtesy of Grace Wales Bonner

CHAPTER 3 STATUS AS STYLE

Emma McClendon

The idea that clothing is a way to display status is nothing new. Take, for example, the stereotypical image of a king clad in fur, jewels, and a crown. As G. Bruce Boyer points out, "There was no question about Louis XIV's status when he walked into the room, dripping in yards of ermine, scarlet velvet plush, and gold embroidery."[1] The "status" of his ensemble directly related to its material value. Furs, fine metal, precious gems, ornately woven textiles, and costly dyes were all expensive, ostentatious, and recognizable. An ensemble composed of these elements immediately conveyed the wearer's wealth, dominant social position, and, therefore, power. Today, furs and brocades have been replaced by logos, brand names, and "It" bags.

Status dressing, however, is not simply about wealth. Sumptuary laws that closely controlled access to certain types of garments and materials existed in Europe in different forms from the Middle Ages through the Ancien Régime. According to these ordinances, a shop merchant could not purchase an ermine lined cape, even if he saved the money to pay for it. These laws were intended to carefully guard the sartorial language of aristocratic power by frustrating the aspirational impulses of the masses. As Philippe Perrot explains, these laws "were instruments of political, social, and economic regulation . . . [that] kept social ranks visible and proclaimed the nobles' monopoly of luxury that distinguished them from the rising classes."[2] Under sumptuary laws, wearing a suit of fine red wool embroidered with gold not only showed wealth, but "proclaimed one's right to wear" such finery as an established member of the ruling nobility.

Aspiration has always been a key component of status dressing. Peter McNeil and Giorgio Riello argue, "It would be a mistake to understand the power of luxury by blaming it on the rich and seeing it as a divisive force. In reality, luxury has become something to aspire to for vast strata of society."[3] Rebecca Arnold recognizes this duality of status dressing as the push-pull between "the thrill of exclusion" and "the desire for the unattainable."[4] As sumptuary laws broke down in the wake of the rise of capitalist democracies, the wealthy bourgeoisie emerged as the new ruling class in the cities of Europe and North America. Upward mobility was now possible and status dressing took on new significance. As Perrot explains, "Intermediate classes were becoming integrated into bourgeois society, but unsure of their station, they coveted status symbols."[5]

The tropes of aristocratic status dressing remained—furs, fine fabrics, lavish jewelry—but since these were now available to anyone with the financial means to acquire them, bourgeois status dressing began to focus more on nuanced signs of differentiation. Where courtly attire was boldly visible, bourgeois luxury was rooted in subtle details. As McNeil and Riello describe, true "luxury was the superior taste for those 'in the know' and those 'who counted' in society."[6] Perrot refers to this new hierarchy as one of "distinction"[7] and uses the crinoline as an example:

> A century earlier, panniers had been reserved for noble ladies and wealthy bourgeoises, but crinolines were now worn both by working women who walked about hatless and by behatted ladies who rode in carriages . . . An elegant, custom-made afternoon dress by a famous couturière could cost between 500 and 1,000 francs; its fullness, fabric, color, and the way it was worn all signaled upper class. Another one, purchased ready-made for 50 or 100 francs, of more modest dimensions, with dull or garish tints, and less precisely fitted, betrayed its modest origins.[8]

◀ Look 6 from Gucci spring 2018 ready-to-wear collection by Alessandro Michele. Photo courtesy of Gucci

Although the two crinoline styles appear similar, the subtle details of fit, fabric quality, and craftsmanship create a distinction between the two that requires a trained eye to recognize.

When Thorstein Veblen laid out his theory of "conspicuous consumption" in 1899, he recognized that the sartorial hierarchy of the bourgeois world was as much about the performance of status as it was about owning status goods. To truly belong to this world of distinction, a person had to act out his or her social position in manners, posture, pose, mannerisms, and speech within the affluent public spaces of the city.[9] It was not enough to merely wear the correct dress, one had to embody its status. Perrot calls this "the new sumptuary laws of 'proper comportment.'"[10] Like the legal ordinances of past centuries, the bourgeois obsession with distinction aimed "to defend the elite from two aspects of the same danger: imitation, which produces too many pretenders . . . or excess, which produces loud, vulgar parvenus."[11] In other words, it aimed to protect their language of power.

When Pierre Bourdieu was writing his treatise *Distinction* eighty years after Veblen, he recognized the same complex system of behaviors among twentieth-century consumers. He called the layers of "comportment" surrounding an individual that person's "habitus." Bourdieu observed that by the 1970s, the hierarchy and social practices of bourgeois capitalist society had become so engrained in everyday life over generations that many people considered the norms of their habitus natural. They failed to recognize the ways they expressed social status (and, by extension, power) in their everyday behaviors, including how they dressed.

Today, the performance of luxury and status occurs much more within the digital landscape of Instagram than the public spaces of the bourgeois city. The advent of branding in the late twentieth century ushered in a new era of conspicuous consumption, during which the logo replaced the subtle comportment of fashionable status dressing. Just as the ostentatious finery of courtly dress was replaced by the subtlety of bourgeois fashion, the rise of the "brand" transformed status dressing once again and made everyday products into luxury commodities.

In *No Logo*, Naomi Klein outlines how commodity-based businesses like fashion began restructuring during the 1980s to "primarily produce brands as opposed to products."[12] At the center of this strategy were *images*. Images and advertisements created a personality, identity, or lifestyle for a brand and connected it to a distinctive logo. Companies could then slap this logo or brand name on a variety of products from sunglasses and lipstick to purses and loafers and sell them at a premium—a "luxury" price—as an extension of this lifestyle. With branding, luxury fashion companies were poised to make massive amounts of money.

Products exist in a hierarchy underneath the umbrella of a brand. The most recognizable, valuable products lend prestige to an entire range of other goods. For example, the classic

◀ Pierre-Thomas Leclère, *Galerie des modes et costumes français*, 1912 (originally published 1779), volume 2, plate 88, hand-colored print. Image courtesy of Fashion Institute of Technology | SUNY, FIT Library Unit of Special Collections and College Archives

◀ Photograph of Sarah Olivia Newland Ripsom wearing the ermin-lined cape now in The Museum at FIT collection, c. 1892 (83.125.1). Although she was not a member of royalty, Ripsom appropriated the stately fur for her dramatic evening cape

two-piece Chanel wool suit has become central to the contemporary Chanel brand's French bourgeois sophistication. After taking over Chanel in the 1980s, the late Karl Lagerfeld recreated the suit each season in an adapted form to fit a collection's theme. Of course, couture clients could continue to order versions of the classic suit as a bastion of the brand's heritage and identity. Details from the suit, such as its distinctive gold chain, have been replicated on other products —the chain as bag handles and necklaces—and the interlocked, double-C logo has come to adorn everything from surf boards to T-shirts.

T-shirts, puffer coats, and sneakers, once bastions of utilitarian clothing, are now staples of the most storied fashion houses. Why pay $3,000 for a red puffer coat from Balenciaga when you can buy a red puffer coat from fast-fashion company ASOS for $35? The coats differ in many subtle ways, such as their cut and construction, weight, and the ways they fit on the body. But one obvious feature that changes the *look* of the Balenciaga coat is the brand name prominently embroidered on its back collar and matching scarf. This is not a nuanced nod to other consumers "in the know." This is a loud status statement, plainly proclaiming to anyone who sees it that the wearer has the economic power to pay $3,000 for a puffer coat.

Again, here is the tension Arnold touched on between exclusion and desire. While the aristocratic nobility and bourgeois elite carefully guarded their sartorial status symbols with legal ordinances and "proper comportment," status dressing today is wide open for consumption by the masses. The business model of major fashion brands is rooted in both creating an air of exclusion and in making consumers feel like they can access it at any price point, whether they are buying a lipstick or a full runway look. As McNeil and Riello observe, "Today's consumers think that luxury is something that everyone should aspire to."[13] This is the paradox of contemporary status dressing—accessible luxury.

While malls and department stores falter, luxury fashion brands continue to grow, posting colossal numbers and exceeding expectations. At the end of 2018, Gucci was the fastest growing luxury brand at $12.9 billion, up thirty percent from 2017.[14] Interestingly, a major boon for Gucci in 2018 was a collaboration with Dapper Dan, a Harlem-based designer who made his name in the 1980s designing logo-covered knock-offs of Gucci, Louis Vuitton, and others because they refused to sell their products in a predominantly black neighborhood for fear it would "tarnish" the status of their brands. The luxury brands eventually sued Dapper Dan and put him out of business. Over twenty years later, he has helped create logo-dense, status products that have propelled Gucci to immense growth. The cycle of exclusion and desire continues. Although the form that status dressing takes shifts and evolves, the desire for status dressing shows no sign of dissipating.

▶ Balenciaga by Demna Gvasalia, puffer coat, red polyester, duck down, metal, fall 2016, France, The Museum at FIT, 2016.113.1, Museum purchase

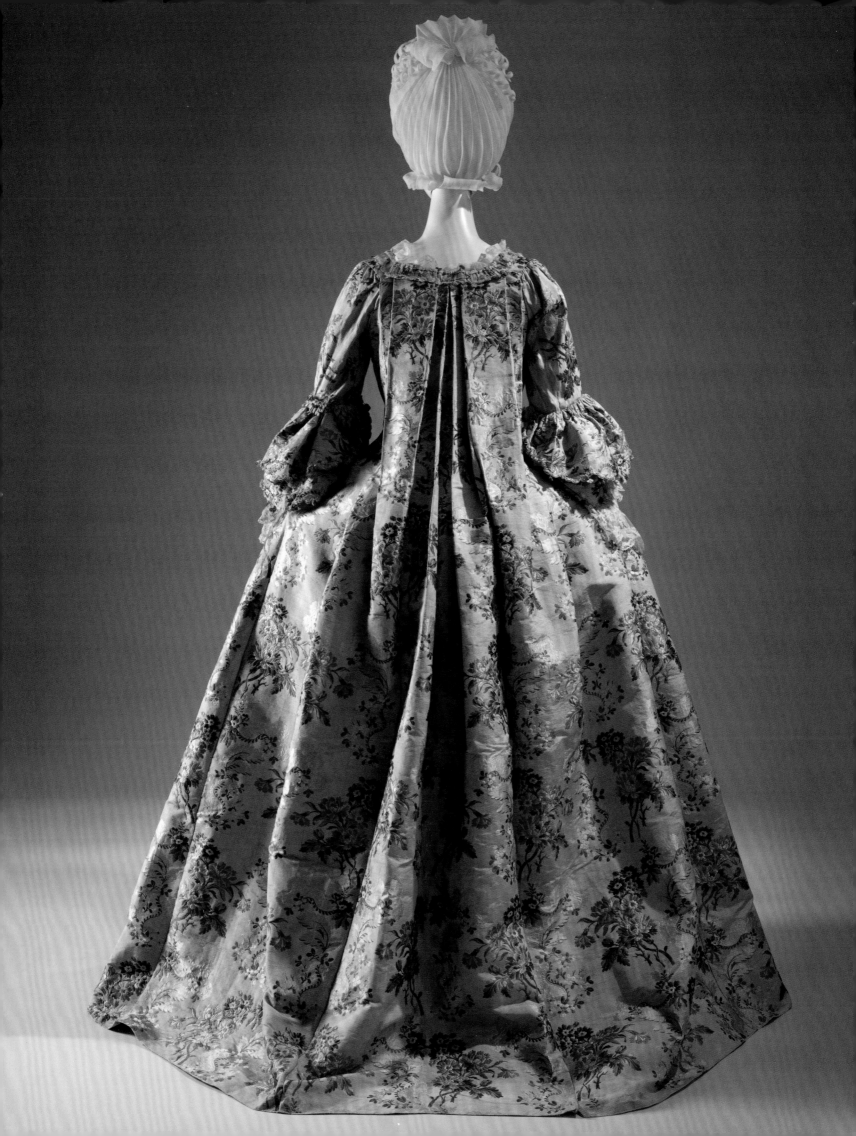

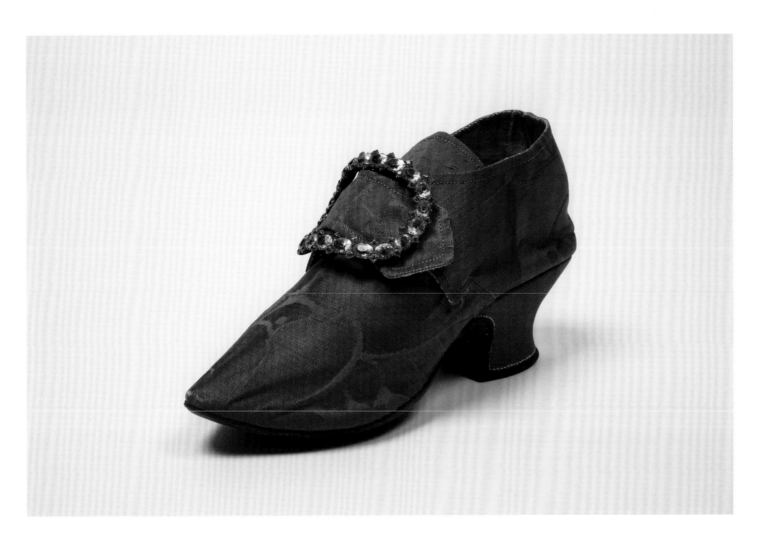

◀ *Robe à la française*, brocade
silk jacquard, 1760–75, USA,
The Museum at FIT, 2017.2.1,
Museum purchase

*A robe à la française is a style
of eighteenth-century court
dress with an open front,
elaborately ruffled sleeves,
large pleat (or "sack") at the
center back, and panniers
(padded undergarments worn
on the sides and underneath
the skirt to widen the hips).
These construction elements
highlight the incredible
amount of fabric used to make
the garment—expensive fabric
that would have instantly
signaled the wearer's status
among the elite.*

▲ Shoes, green silk, linen,
leather, 1740–45, England,
The Museum at FIT, 2013.3.1,
Museum purchase.
Buckles, paste, metal, eighteenth
century, England, The Museum
at FIT, 2013.3.2, Museum
purchase

*Made of ornate silk and linen
with shimmery buckles, these
shoes would have been a sign
of the wearer's wealth and
status. Some eighteenth-
century buckles were indeed
made with fine gemstones,
further signaling the wealth of
their owner. If a person could
wear gems on their feet,
imagine what they could afford
to wear around their neck.*

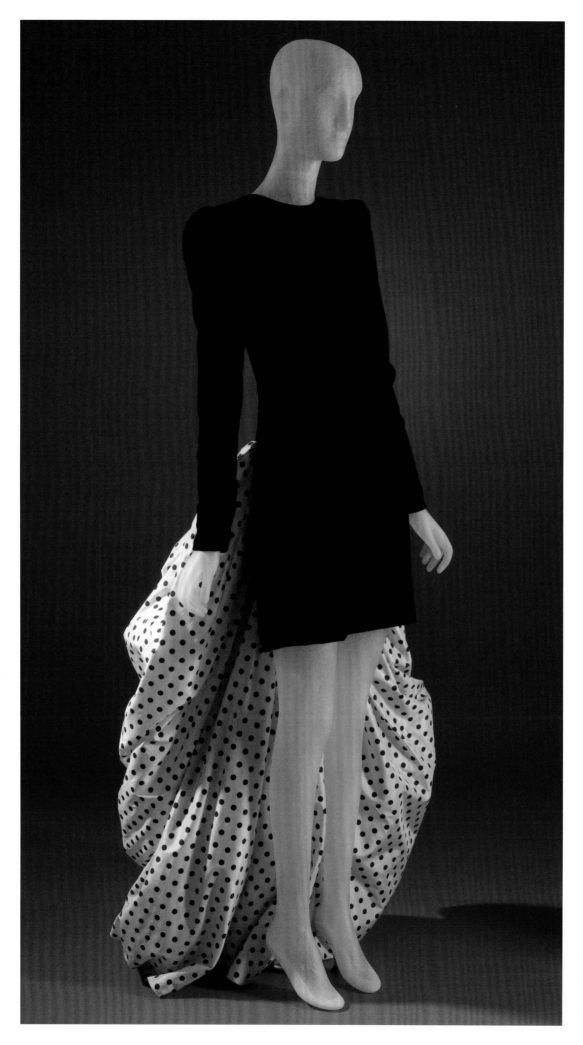

◀ Carolina Herrera, dress, black velvet and white polka-dot silk taffeta, fall 1988, USA, The Museum at FIT, 2005.48.8, Gift of Carolina Herrera, Ltd

This cocktail dress by Carolina Herrera recalls the ermine evening cape from the 1890s. The black velvet and ermine have been reinterpreted as a velvet mini dress with a dramatic black-and-white, polka dot train in supple taffeta. It, too, is a statement piece designed to help the wearer make an entrance, announcing her status at a 1980s social event.

▶ Cape, ermine and black velvet, 1892, USA, The Museum at FIT, 93.125.1, Gift of Mrs. Francis Hamlin.
Evening dress, yellow silk velvet, silk satin, lace, rhinestones, 1893, USA, The Museum at FIT, 2013.51.7, Gift of DuBois Family

By the late nineteenth century, materials like ermine fur that were once reserved for royalty became available to anyone with the money to purchase them. This evening cape of black silk velvet and ermine mimics the look of royal robes. However, it was a symbol of the wearer's status among the upper echelons of bourgeois society.

◀ Christian Dior, coat, leopard fur and silk, 1960–63, France, The Museum at FIT, 91.121.2, Gift of Mrs. Sylvia Slifka

In 1962, First Lady Jacqueline Kennedy had a leopard pelt made into a coat by Oleg Cassini, sparking a massive trend for this exotic fur that led to the near decimation of the great cat. Fur has historically been a potent power symbol across cultures, from African tribes to the courts of Europe. Rebecca Arnold sees the lure of fur as "the fantasy of power tinged with the cruelty of the kill."[1]

▲ Jacqueline Kennedy with President John F. Kennedy wearing a leopard skin coat designed by Oleg Cassini, March 8, 1962. Everett Collection Historical / Alamy Stock Photo

▶ Dolce & Gabbana, coat, faux fur with tiger print, 1992, Italy, The Museum at FIT, P92.58.16, Museum purchase

During the 1990s, many high fashion brands moved away from using real fur, thanks in large part to activist groups like PETA. But this did not stop the desire for the look of fur. Dolce & Gabbana exaggerates the eye-catching quality of fur with a tiger print, embracing the faux quality of the material. This complicates the "status" of the coat—it is an expensive designer item, but made of imitation material.

◀ Chanel, suit, wool tweed, braiding, ribbon, metal, 1963–64, France, The Museum at FIT, 80.13.1, Gift of Mrs. Georges Gudefin

Chanel debuted her tweed suit in 1953 when she reopened her couture house after World War II. It has become one of the most recognizable high fashion looks of the twentieth century, immediately conjuring associations with elite status.

▶ Chanel by Karl Lagerfeld, suit, pink wool, cotton, synthetic, white cotton, spring 1994, France, The Museum at FIT, 94.80.1, Gift of Chanel Inc.

Karl Lagerfeld reinvented the Chanel tweed suit with each collection. In this version, he pairs the jacket and skirt with a matching corset and completes the look with a simple cotton T-shirt instead of a silk blouse. Stamped with Chanel's double-C logo, the T-shirt updates the suit for the new logo-driven era of status dressing.

◀ Chanel by Karl Lagerfeld, necklace, gold-plated metal, fall 1991, France, The Museum at FIT, 2013.56.1, Gift of Depuis 1924

This bold necklace was a key accessory in Karl Lagerfeld's 1991 "hip hop" collection for Chanel. Lagerfeld drew inspiration from artists such as Run-DMC and Salt-n-Pepa, replicating styles like the gold "dookie" chain. While the "dookie" chain was a symbol of power for black hip hop artists—ostentatious luxury and success in the face of Reagan-era racial conservatism—here it has become a branding device for high fashion.

▶ Fendi, "Baguette" bag, hand-painted python, gold thread, gold hardware, silk brocade, fall 2001, Italy, The Museum at FIT, 2007.25.1, Gift of Fendi

The so-called "It" bag craze took off during the late 1990s. Fendi's "Baguette," introduced in 1997, was among the most desired styles. Available in a variety of luxury materials, including python skin and 18K gold, the bag could cost upwards of $5,000, but this did not deter customers. The high price tag and prominently placed logo made the "Baguette" an undisputed status item.

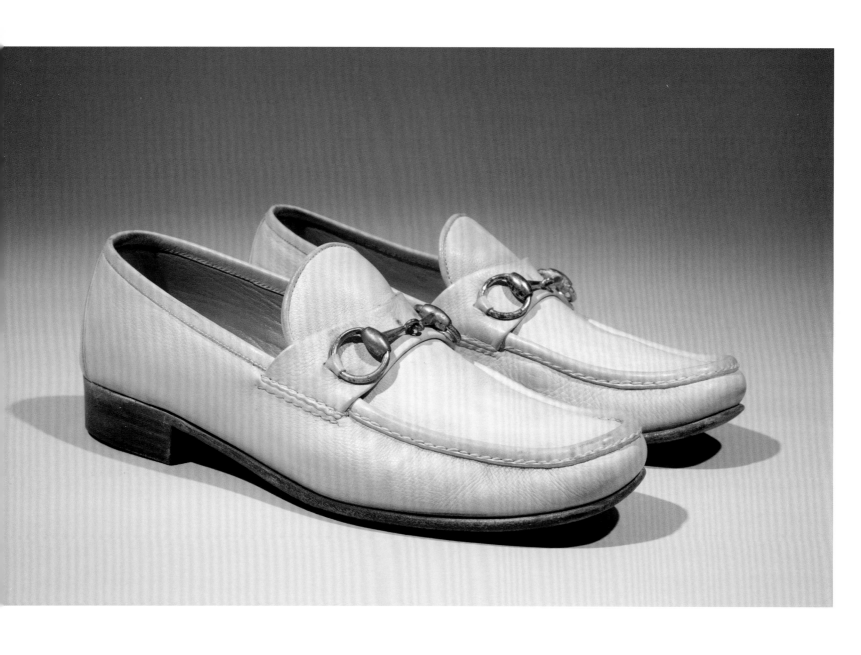

▲ Gucci, men's shoes, white leather and metal, 1955, Italy, The Museum at FIT, 78.86.1, Gift of Frank Yacenda

Gucci first introduced its signature loafer in 1953. Modeled after Native American moccasins, it was designed to be comfortable and casual. The style soon became synonymous with the elite "jet-set" lifestyle, positioning the distinctive shoe—with its horsebit gold hardware—as a status symbol of leisure and luxury.

▲ Gucci by Alessandro Michele,
shoes, multi-color canvas, leather,
metal, spring 2016, Italy,
The Museum at FIT, 2017.17.1,
Gift of Alyson Cafiero

*Loafers have been a fixture
of the Gucci company since
the 1950s. Today, creative
director Alessandro Michele
has updated the signature
style with a longer toe and
a range of brightly colored,
romantic designs—but the
distinctive horsebit hardware
remains intact, ensuring
they are recognizably
a Gucci product.*

◀ Dapper Dan of Harlem, jacket, lambskin leather, "High-Tek Leather," c. 1985, The Museum at FIT, 2013.87.1, Gift of Dapper Dan of Harlem

Daniel Day (aka Dapper Dan) printed the leather for this jacket to imitate German brand MCM. Day's Harlem boutique became renowned for custom creations covered in luxury logos, such as those for Louis Vuitton and Gucci, *that helped usher in the "logomania" trend of the 1990s. In 2018, Day launched a collaboration with Gucci and reissued some of his signature styles, including this jacket (of course, the MCM logo was swapped for Gucci's).*

▲ Models in looks from Dapper Dan's 2018 collaboration with Gucci. Photo courtesy of Gucci

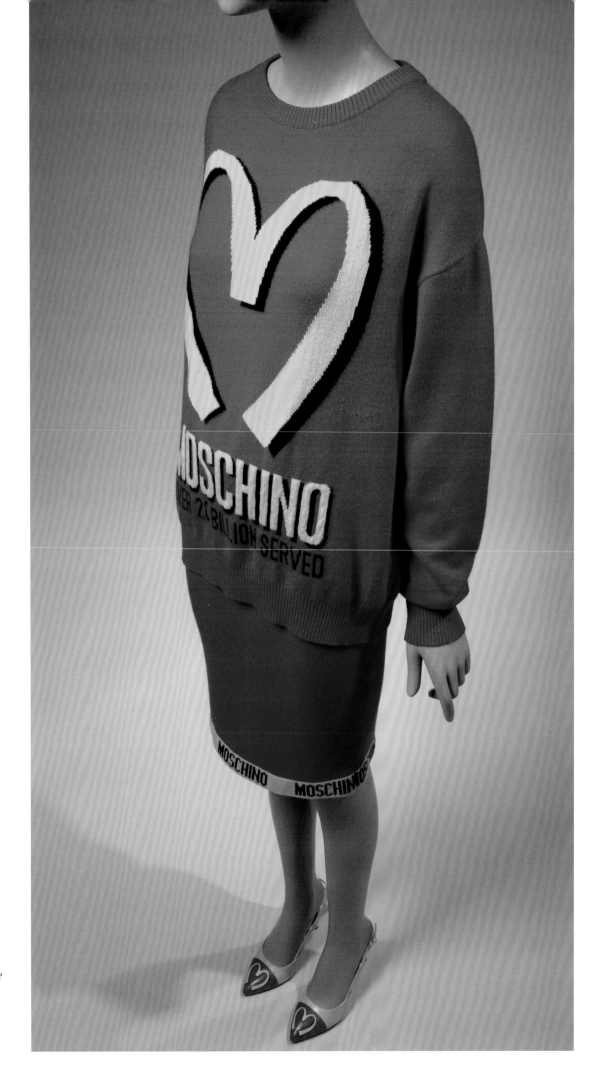

▶ Moschino by Jeremy Scott, ensemble, red and yellow wool, cashmere, leather, fall 2014, Italy, The Museum at FIT, 2014.46.1, Gift of Moschino

Jeremy Scott took a playful approach to "logomania" in his first collection for Moschino by creating looks that parodied the uniforms and branding of fast-food chain McDonald's. Despite its tongue-in-cheek tone, the wearer would still become a walking billboard for the Italian brand—with "Moschino" writ large under a slightly curved, McDonald's-esque "M."

◀ Balenciaga by Demna Gvasalia, puffer coat, red polyester, duck down, metal, fall 2016, France, The Museum at FIT, 2016.113.1, Museum purchase

In his first collection for Balenciaga, Demna Gvasalia showed dramatic puffer coats—his twenty-first century interpretation of Balenciaga's famed swing coats. Branded for the label-savvy consumer and stuffed with high-quality duck down, the hyper-warm puffer is Gvasalia's status fur for the new millennium.

▶ Vetements by Demna Gvasalia, T-shirt, yellow cotton and elastane blend, spring 2016, France, The Museum at FIT, 2018.6.1, Museum purchase

Demna Gvasalia opened his spring 2016 collection for Vetements with a bright yellow T-shirt emblazoned with the letters DHL across the chest. It is a near exact copy of the uniform shirt issued to deliverymen of the DHL shipping company. There is no parody or adaptation here. It is a biting twist on the branded status dressing of contemporary high fashion.

AN EIGHTEENTH-CENTURY EMBROIDERED SUIT

Peter McNeil

How omnipresent was the "little black suit" for men in the nineteenth century, and when did it really come in? Even in the eighteenth century people were arguing about what colors and textiles British men really wore. The famous actor and playwright David Garrick read a French travel account by Grosley about London in 1770 which suggested that British men were simply dressed. He complained, "what I have read is Error from beginning to ye End . . . I never saw a Gentleman dress'd in London without his sword, & the Physicians wear Cloaths of all Colours, like other People."[1]

Such a colour might even be red!

This Scottish woollen embroidered suit and matching waistcoat dates from about 1745. It is likely a court suit rather than the professional attire worn by professional men of that century, in part due to the expensive luxury of its embroidery. It has the fullness and focus on the lower waist that characterized men's fashion in the first half of the century: men looked a little pear-shaped, which suited mature men at a time when fashion was not yet synonymous with the young. The ensemble is made from a fine British wool of such quality that the edges have been cut and left raw, such was the fineness and density of the weave. For centuries, England and the Low Countries had excelled in the production of these super fine wools, whereas continental Italy and France produced luxury plain or brocaded silks and silk velvets. It is therefore not surprising that the silk, satin, and silk-velvet clothing that characterized continental court dress for men was seen less often in the streets of Britain. Many British men preferred more practical woolen clothing that was well fitted and based on cuts also suitable for riding and sporting dress: it is just plausible that a man in this outfit could mount a horse without splitting his clothing (although in reality he would have traveled by carriage).

The three-piece suit was a late-seventeenth-century innovation and some historians believe the long coat had Turkish or Persian origins. The format eventually became known as the *habit à la française*, a modern, international suit consisting of a coat (*justacorps*) and skirted waistcoat (*veste*), both of which could be made of very expensive brocaded silk, sometimes trimmed with extra frogging or *passementerie*, or silk or velvet embroidered along the edges and at the pockets. The suit was worn with knee breeches (sometimes, though not always, matching) and silk stockings. Here we have the pleasant survival of coat and matching waistcoat, which is not as common as might be expected.

Woolen suits for wealthy men were often trimmed with "galloon" or thick, textured braid. This can be seen in portraits and prints, and in the many paintings of British men on the Grand Tour in Italy. It is less common to see surviving embroidered wool.

◀ Man's formal set, wool, silver-gilt thread, purl, sequins, silk taffeta, linen, cotton fustian, 1745, Scotland, The Museum of FIT, 2013.3.3, Museum purchase

▶ Pierre-Thomas Leclère, *Galerie des modes et costumes français*, 1912 (originally published 1779), volume 1, plate 77, hand-colored print. Image courtesy of Fashion Institute of Technology | SUNY, FIT Library Unit of Special Collections and College Archives

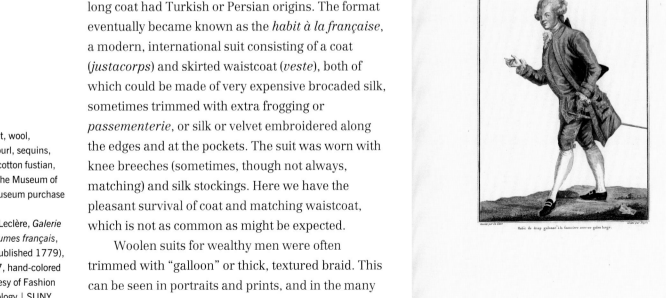

And what spectacular embroidery it is! Stylized botanical motifs and palmettes have a sense of the exotic, a little Turkish even, amplified by the glamor of the silver-gilt wrapped thread, purl with added spangles. The buttons, too, are gilded, and the tone harmonizes beautifully with the hue and nap of the cloth.

It is also very on trend. According to the plates from the first fashion periodicals, the French preferred to use silver thread on summer suits and gold for winter. Our Scottish embroiderer cleverly created a garment that resolves well in three dimensions: an elegant and playful touch of embroidery at the nape of the neck is echoed in that which runs up the rear vents, which would have shimmered and shimmied as the man moved.

The customer was clearly a big spender: he directed the tailor to use cloth rather than the customary linen at the back of the waistcoat, even though it would never be seen. As the outfit has a Scottish noble provenance, it might have kept him warm at a court, diplomatic, or ceremonial appearance, such as a levée or "drawing room," when dignitaries were present. The embroidery is likely of local production, as Scotland had a fine professional craft output and from 1749 an Act of Parliament had banned "the importation and wear of foreign embroidery and brocade, and of gold and silver thread . . . or of other work made of gold or silver wire." Such a suit was expensive: during the 1760s, a plain velvet French suit was imported by Lord Riverstone for about $5,000 in today's money, plus $500 duties (taxes). Such a price point is akin to a piece of Tom Ford or Dolce & Gabbana men's haute couture today, but this piece has the added luxury of the embroidery and buttons.

Men's suits during this period were more varied than many people now imagine. They took advantage of new materials and imports, intricate techniques and the changing seasons. This outfit would have been worn with a linen shirt trimmed with fine lace. Shirts were changed and washed as often as budget allowed and this is in part how the outer suit was kept clean. Although cotton was not much used for men until late in the century, a French suit illustrated here depicted trimmings of a glazed cotton chintz, either imported from India or one of the southern French

▼ Detail of man's formal set, 1745 (see p. 72)

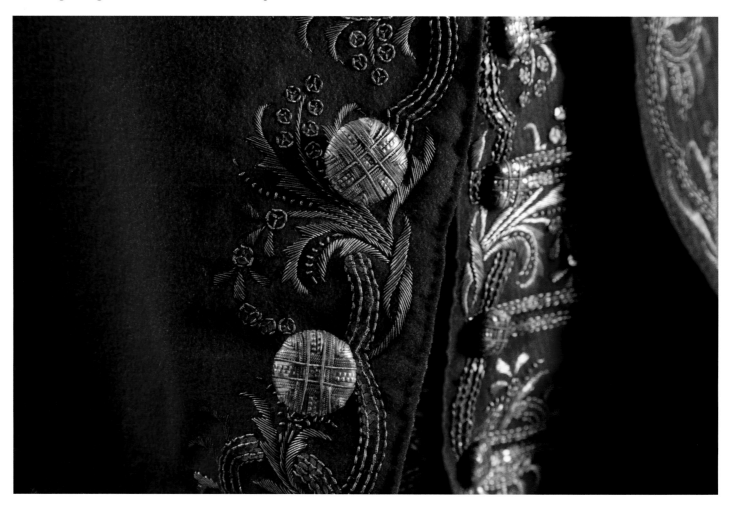

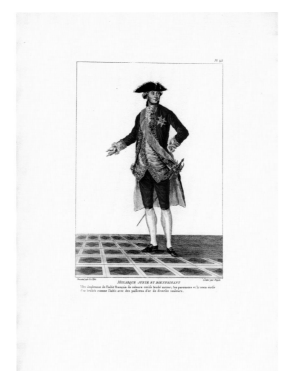 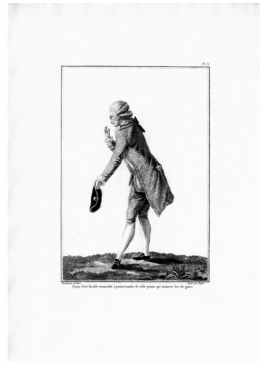

local productions. Men's clothes were not static but active participants in the fashion system and there was silhouette change every ten years or so, not dissimilar to today.

Men changed accessories such as buttons and snuffboxes, although this was a prerogative of the very rich. Managing their appearance took some time: they had to have their wigging attended to, regularly buy new silk wig bags as they wore out, repair and remodel their clothes and linings, look at the new designs for dress swords, and keep an eye on fashions in shoe buckles.

The rich color and well-balanced embroidery of the suit here remind us of several things. Fashion was not just important in big cities like Paris and London but elsewhere, too. A woollen suit is not necessarily "boring." British style can be just as exciting as French or Italian, and in fact by the end of the century the youth of Western Europe wanted to look more British. Yes, the English dandy of the Regency period stripped back his wardrobe to the essentials of the finest shirt, cravat linen, and woollen broadcloth or worsteds. But perhaps they had in the back of their minds that English wool, with its ability to be shaped by the iron and cut perfectly by tailors, provided a reservoir of practical and artistic ideas that could shape fashion for a new century.

▶ Pierre-Thomas Leclère, *Galerie des modes et costumes français*, 1912 (originally published 1778), volume 1, plate 43, hand-colored print. Image courtesy of Fashion Institute of Technology | SUNY, FIT Library Unit of Special Collections and College Archives

▶ Pierre-Thomas Leclère, *Galerie des modes et costumes français*, 1912 (originally published 1776), volume 1, plate 72, hand-colored print. Image courtesy of Fashion Institute of Technology | SUNY, FIT Library Unit of Special Collections and College Archives

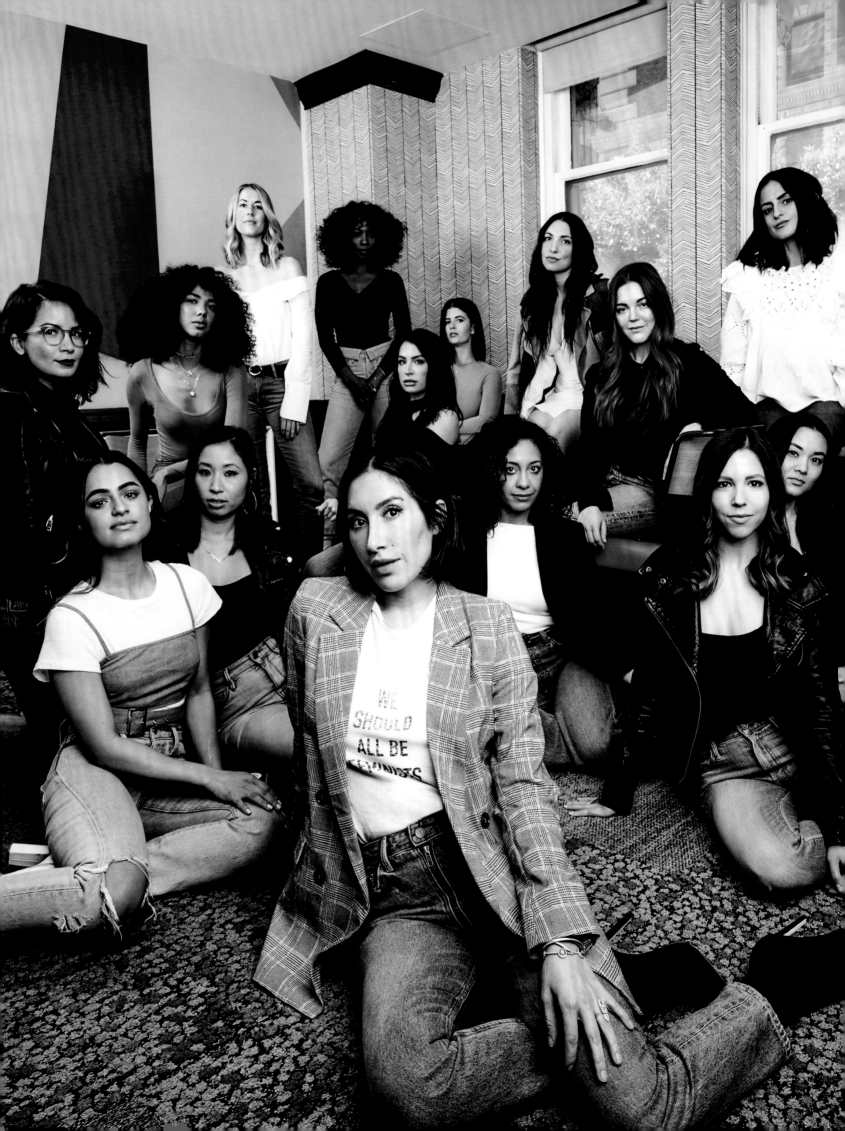

CHAPTER 4 FASHIONING RESISTANCE

Emma McClendon

In April 2018, *Women's Wear Daily* published a special supplement focused on the beauty industry. On the cover, a group of prominent female influencers stare directly at the camera, straight-faced, wearing blue jeans and T-shirts, with a few in black leather "biker" jackets. Front and center, hair-stylist Jen Atkin wears a Dior T-shirt with the words "We should all be feminists" printed in bold, block letters across her chest. The cover story, titled "Power to the People," details how these social media stars (each with their own fledgling beauty brand) engage with their followers online in order to give "their community" a voice in the product development process.[1] It is an article about how to monetize social media, but its images blatantly harness the language of resistance to visually communicate a specific kind of "power."

Blue jeans, printed T-shirts, and black leather jackets are some of the most common symbols of resistance in clothing. They have become visual shorthand for a certain type of power, what political scientist Erica Chenoweth calls "civil resistance." It is a form of power that is subversive rather than dominating, the power of the subordinate and marginalized to assert themselves in the face of authority. As Chenoweth describes, "Civil resistance is, by its own definition, transgressive and non-institutional." It uses "unarmed civilian power" in "nonviolent methods such as protests, strikes, boycotts, and demonstrations, without using or threatening physical harm against the opponent."[2]

This is a form of power rooted in optics. The spectacle of resistance allows a marginalized group to be collectively seen and heard in order to voice issues to a governing authority. Think of the bright pink pussyhat of the Women's March, or the vibrant yellow vests of French protesters. This type of power also exists at an individual level, as the "agency" to assert one's identity and outlook through clothing—particularly for "those who feel alienated from the main flow of political life, whether because of gender, class or ethnicity," as Rebecca Arnold has put it.[3]

Of course, each archetype of "resistance" dressing has been worn by advocates of opposing issues, at different points in time and in varying forms. For example, both "Pro-Life" and "Pro-Choice" advocates wear T-shirts to make their outlook on abortion plainly visible. T-shirts, along with jeans and black leather jackets, have also been incorporated into everyday wardrobes and high fashion collections to give a certain "edge" to fashionable dressing—evident in the *Women's Wear Daily* image. This is the tension between resistance clothing and "fashion." The former is seen as a vital tool of individual agency and collective protest—a way to make a group's (or individual's) identity clearly visible by means of a single symbol. The latter, however, is often viewed as surface-level appropriation that strips resistance garments of their meaning, transforming them into empty commodities for the wealthy. But the relationship between resistance movements and fashion is not so simple. There is not always a binary division between political agency and stylish commodity: resistance can be concerned with style, and fashion can be a vehicle for resistance.

This tension has recently been visible. Within the current socio-political climate following the 2016 U.S. presidential election, the term "resistance" has taken on new urgency, both in the U.S. and abroad. As a result, "resistance" clothing has been increasingly present on the runway, in magazines, and in retail outlets. It may not be surprising that when confronted with the divisive landscape of politics today, many consumers and the fashion industry at large find refuge in familiar sartorial symbols of civil resistance. However, we cannot dismiss all of the fashionable resistance items sold within this cultural environment as mere appropriation. For example,

in the case of the Dior T-shirt, its literal language does in fact align its wearer with a political position, commodity or not.

Shown in late September 2016 as part of the spring 2017 collection, the Dior shirt's design pre-dates Donald Trump's shocking win, "nasty woman" comment, and the release of his hot-mic recording about grabbing women's genitalia. The printed phrase—"We should all be feminists"— is a reference to Chimamanda Ngozi Adichie's essay of the same title and fits within the overall feminist theme of the collection, which also drew inspiration from Linda Nochlin's famous article "Why Have There Been No Great Women Artists?" It was part of Maria Grazia Chiuri's debut collection for Dior, which had never had a female head designer before. As such, Chiuri was consciously adopting the sartorial language of resistance to make a clear break with the past and assert a new women-for-women outlook for the brand under her direction.

But by the time the shirt hit stores in May 2017, not only had Trump won, but the first Women's March had stormed Washington, D.C. and "nasty woman" had become a rallying cry around the world. Many celebrities appeared in the Dior shirt on Instagram before its release even as the political storm continued to build, thus transforming the T-shirt into a symbol of solidarity with the growing feminist sentiment in popular culture. The most famous example is a post by Rihanna from January 22, 2017—the day after the first Women's March on Washington, D.C. The post received over 1.7 million likes.

Of course, with a price tag of nearly $800, the T-shirt was not affordable for the average civilian. It *is* an exclusively-priced, luxury commodity for celebrities and the wealthy. But it was also worn as a statement of resistance in a highly visible way, prompting the manufacture of cheaper copies and the spread of Adichie's title "We should all be feminists." Posters and hashtags reverberated across the digital landscape as a call to civil resistance.

This is not to suggest that fashion adapted from resistance clothing is worn as a political statement. The "hippie look" of the 1960s counterculture movement is perhaps the most obvious example of a resistance aesthetic that was co-opted by the fashion industry and turned into a new, chic look. The "hippies" who emerged from the San Francisco Bay Area viewed clothing as a primary tool to convey their political outlook. The natural fibers, hand-embroidery, patched

personalized decorations, and secondhand denim jeans that defined their "look" all carried a political message decidedly against the plastic, prepackaged, and disposable world of postwar consumerism, which they felt was destroying the planet and fueling international conflicts. Yet, their highly distinctive style was appropriated by the very consumer industries they were protesting against. From Coca-Cola commercials to Levi's advertisements, the hippie image went mainstream.

"Hippie chic" became a major fashion trend during the early 1970s. Denim, patchwork, and tie-dying techniques, for example, all found their way into high fashion on dresses and suits, as well as shoes, bags, and swimwear. And the trend has never fully gone away, resurfacing again and again every few years. In 1999, Tom Ford shocked the press with versions of distressed "hippie" jeans that retailed for over $3,000. Chiuri herself has been criticized for appropriation of the quilted, patched, and distressed "protest" aesthetic of 1960s counterculture to make high-end Dior ready-to-wear.

◄ Shorts, cotton denim and embroidery, c. 1970, USA, The Museum at FIT, 2016.20.3, Gift of the Nancy Hariton Gewirz Collection

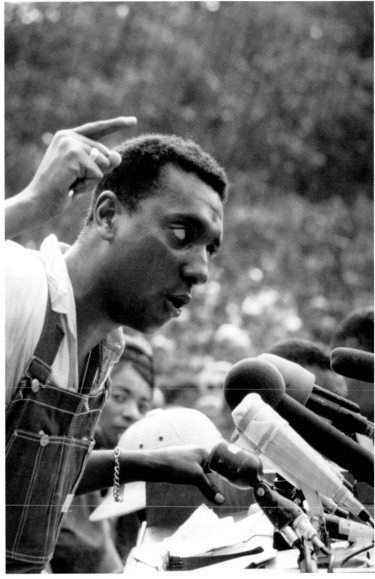

Some designers view the runway as a site for social engagement and activism. Patrick Kelly, for example, continually used his work to engage with aspects of African American identity during the 1980s. From stretch spandex leggings printed to resemble Kente cloth to his own brand logo that reclaimed the pejorative image of the golliwog, Kelly continually referenced the black American experience. Even his own personal "uniform" of blue denim overalls simultaneously alluded to the legacy of black sharecroppers in the American South and the preferred protest outfit of the Student Nonviolent Coordinating Committee (SNCC) during the Civil Rights Movement.

Today, designer Kerby Jean-Raymond has used his brand Pyer Moss as a platform for social justice. Much of his work weaves together the recognizable sartorial language of resistance with text and images designed to bring awareness to the systemic racism and marginalization of black people in America. Some of this work takes direct aim at the fashion industry itself, such as a black leather "biker" jacket with the words "We already have a black designer" written across the back. It is a reference to the tokenism that has become rampant practice across the fashion industry. Here we see the garment, and the fashionable body by extension, transformed into a billboard to call out the transgressions of the fashion industry itself.

We are living at a time in which the political power ingrained in our clothing is becoming increasingly apparent, from "MAGA" hats to "pussyhats." Perhaps when clothing items themselves take on such potent meaning, the runway becomes the natural site of resistance.

▶ Designer Patrick Kelly in his signature overalls during a runway show finale, March 15, 1989. Photo by Keith Beaty/Toronto Star via Getty Images

▶ SNCC leader Stokely Carmichael speaking to a crowd at a rally on the Mississippi State Capital steps. Photo © Flip Schulke/CORBIS/Corbis via Getty Images

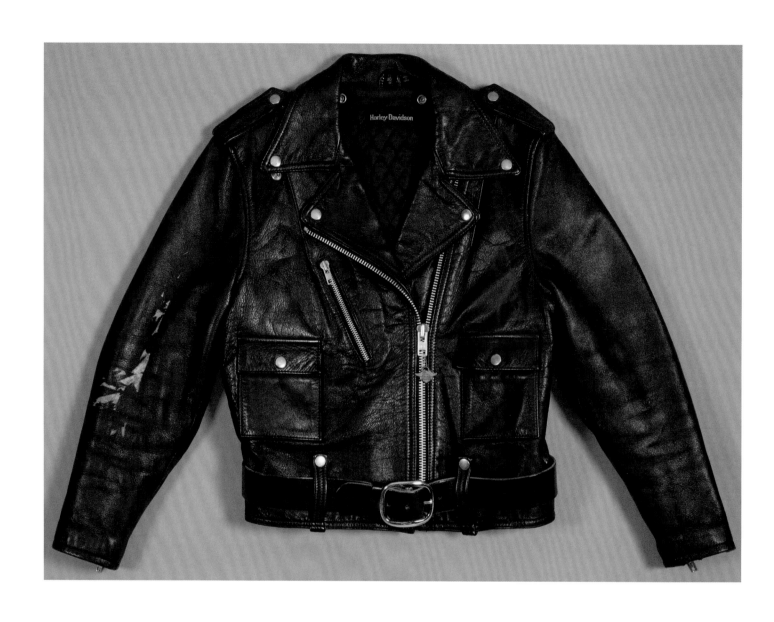

▲ Harley-Davidson, jacket, black leather and metal, 1983, USA, The Museum at FIT, 2013.30.1, Gift of Pepper Hemingway

The "biker" jacket was originally designed by Irving Schott in 1928. Dubbed the Perfecto, it was distinctive for its asymmetrical, cross-body design, durable black leather, and exposed metal hardware. After World War II, motorcycle gangs adopted the jacket as a uniform, often emblazoned with gang signs. Marlon Brando made this "biker" look famous in The Wild One, *which helped cement the leather jacket as a symbol of outlaw rebellion.*

▶ Azzedine Alaïa, dress, black leather and metal, 1987, France, The Museum at FIT, 2013.24.1, Museum purchase

Azzedine Alaïa transformed the "biker" jacket into a body-hugging dress, extending the asymmetrical zipper down the length of the wearer's body. This adds an erotic quality to the look, but the reference is still recognizable. Alaïa was known for his sexy designs during the "power dressing" era of the 1980s.

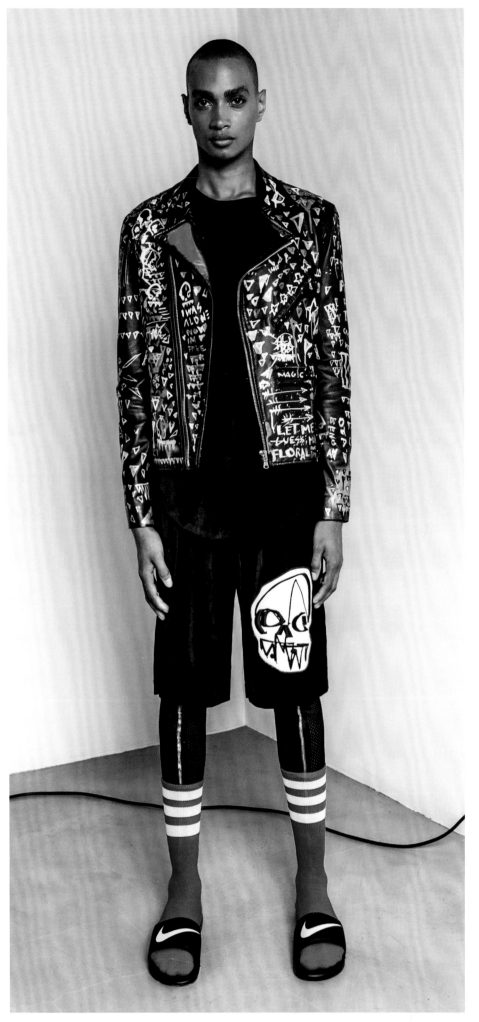

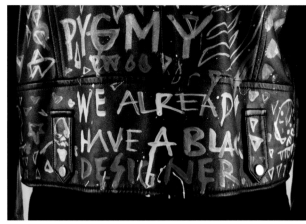

◀ Pyer Moss by Kerby
Jean-Raymond, man's ensemble,
black leather, velour, cotton,
plastic, spring 2016, USA,
The Museum at FIT, 2016.83.2,
Gift of Pyer Moss

*The "biker" jacket in this look
is covered in graffiti-like text
and imagery. Phrases include
"we already have a black
designer" and "poem for the
caged artist." Designer Kerby
Jean-Raymond drew on
the rebellious symbolism of
the jacket to use it as a blank
canvas for commenting on the
racism of the fashion industry.*

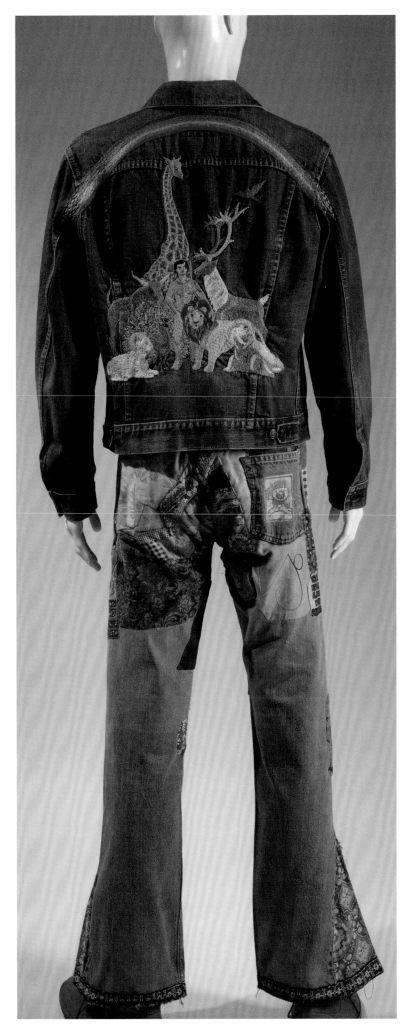

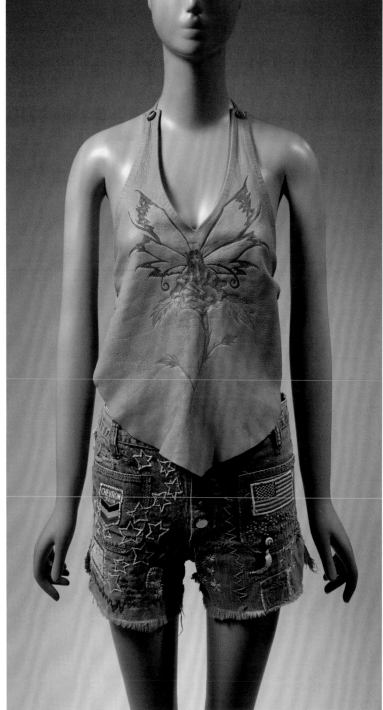

◀ Man's jacket and pants, cotton, leather, silk, embroidery, c. 1970, USA, The Museum at FIT, 2016.20.10 and 2016.20.12, Gift of the Nancy Hariton Gewirz Collection

▲ Halter top and shorts, leather, cotton, embroidery, c. 1970, USA, The Museum at FIT, 2016.20.1 and 2016.20.3, Gift of the Nancy Hariton Gewirz Collection

Each of these garments has been personalized by hand. Hippies used embroidery, patches, and hand-worked leather to create a distinctive style aesthetically opposed to the shiny, plastic, mass-manufactured products of postwar consumerism. They also gravitated toward denim for its working class connotations and often bought it secondhand. Clothing was a tool of protest for hippies —a way for them to make an immediately recognizable political statement.

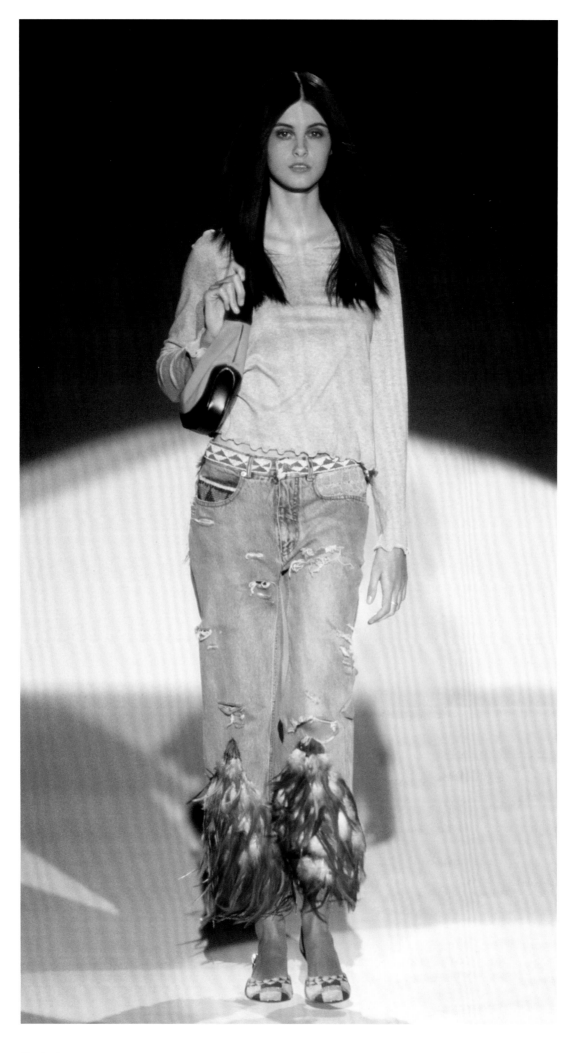

◄ Gucci by Tom Ford, ensemble, blue denim, feathers, beads, cotton jersey, spring 1999, Italy, The Museum at FIT, 2015.7.1, Gift of Gucci. Image courtesy of Gucci

In 1999, Tom Ford showed ripped, distressed, and embellished jeans as part of his spring Gucci collection. Ford was inspired by the way hippies personalized denim during the 1960s, but these are luxury jeans, not protest wear, and cost up to $3,800. More shocking was that the first shipment sold out even before it reached the stores.

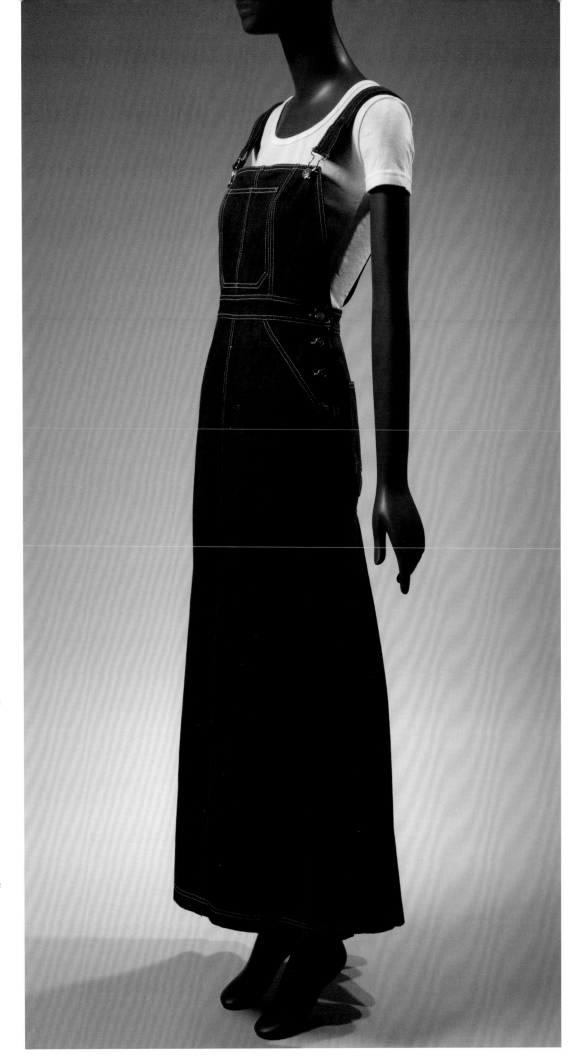

▶ Patrick Kelly, dress, blue denim and metal, fall 1987, France, The Museum at FIT, 2016.82.9, Gift of Bjorn G. Amelan and Bill T. Jones

This dress by Patrick Kelly references his personal uniform and the legacy of SNCC (Student Nonviolent Coordinating Committee) protests. Denim as protest fashion is typically associated with (white) hippies, but denim overalls were a potent symbol of resistance during the Civil Rights Movement for their connection to the history of black sharecroppers. By donning overalls for public protests, SNCC organizers reclaimed denim—once considered a sign of subservient class—as a power statement.

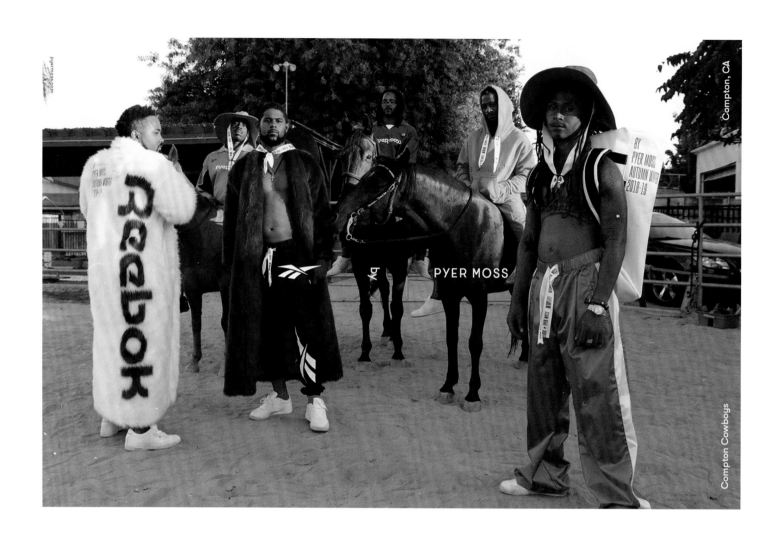

Compton, CA

Compton Cowboys

▶ Pyer Moss by Kerby
Jean-Raymond, ensemble, cotton,
polyester, rubber, metal, fall
2018, USA, The Museum at FIT,
2018.75.1, Gift of Pyer Moss

*The Pyer Moss fall 2018
collection referenced
nineteenth-century, black
cowboys in order to highlight
the whitewashing of American
culture. Kerby Jean-Raymond
fused "cowboy" details like
chaps, yoked tops, and wide
brimmed hats with sneakers,
T-shirts, and track suits. It was
a rebuke of the stereotypical
cowboy—a bastion of white
American masculinity.
The biting slogan "AS USA
AS U" was printed across
the collection.*

▲ Models in looks from
the fall 2018 Pyer Moss collection
produced in collaboration with
Reebok. Photo by Rubberband

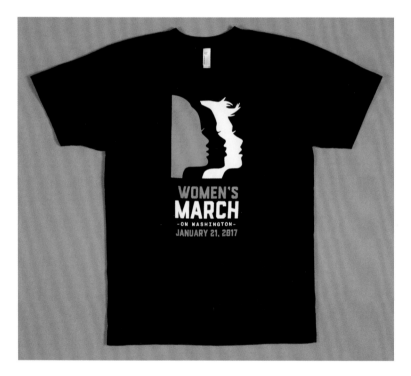

◄ "Silence=Death" ACT UP
T-shirt, black cotton, 2018, USA,
The Museum at FIT, 2018.15.1,
Museum purchase

◄ Women's March T-shirt,
navy cotton, 2017, USA,
The Museum at FIT, 2018.76.1,
Gift of Emma McClendon

▲ G-Star RAW T-shirt, white
"Bionic Yarn" (recycled ocean
plastic), spring 2016, The
Netherlands, The Museum at FIT,
2016.71.1, Museum purchase

▲ Pro-choice T-shirt,
white cotton, 1992, USA,
The Museum at FIT, 92.58.1,
Gift of Margo Seaman

*The T-shirt is perhaps the most
obvious example of protest
fashion. Orginally designed
as a man's undergarment,
the plain, white T-shirt
became a blank canvas for
political rhetoric during
the mid-twentieth century,
allowing individuals to wear
their ideologies on their chests.
This transformation took hold
during the Vietnam protests
of the 1960s and 1970s
and remains a key tool for
civil resistance movements,
such as the Women's March
and Black Lives Matter.*

► Christian Dior by Maria Grazia Chiuri, ensemble, cotton and silk, spring 2017, France, The Museum at FIT, 2019.56.1, Museum purchase

This look was part of Maria Grazia Chiuri's debut collection for Dior. The T-shirt is printed with the title of Chimamanda Ngozi Adichie's famous essay "We should all be feminists." While the shirt commodifies resistance into a catchphrase, it became a feminist rallying cry for the Instagram age.

▲ Off-White by Virgil Abloh, "Hoodie" sweatshirt, black cotton, fall 2018, Italy, The Museum at FIT, 2019.8.1, Gift of Off-White

After Trayvon Martin's death (a black teenager fatally shot by police in 2012 for looking "suspicious" in a "dark hoodie"¹), the hooded sweatshirt became an emblem of systemic racism and civil resistance, particularly within the nascent Black Lives Matter movement. Virgil Abloh's "Hoodie" for the label Off-White combines the power symbol with a play on traditional branding strategies.

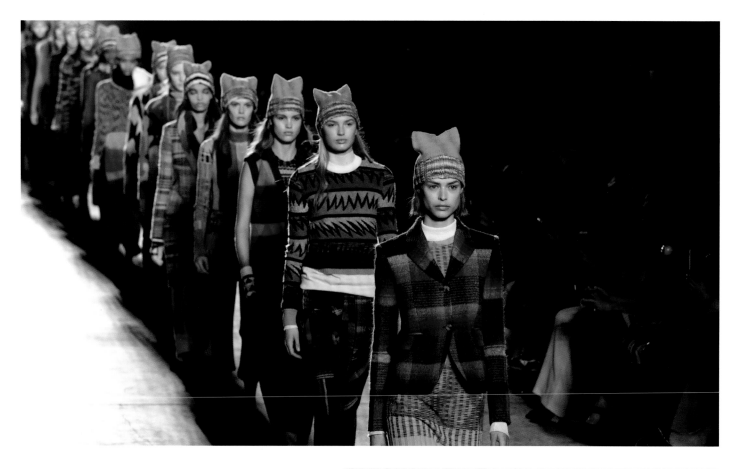

▶ "Pussyhat," pink synthetic wool, 2017, USA, The Museum at FIT, 2018.14.1, Gift of Colleen Hill

Krista Suh and Jayna Zweiman launched the Pussyhat Project website in December 2016 to show knitters how to make pink "pussyhats" for the Women's March. The hat gave the wearer cat-like, "pussy" ears, so that she could reclaim the term "pussy" as a symbol of female power. It was a response to the hot-mic recording of then-candidate Trump boasting about grabbing women "by the pussy." Italian brand Missoni adapted the style for the finale of its fall 2017 collection.

▲ Models during the finale of the Missoni fall 2017 fashion show wearing the brand's "pussyhat," February 25, 2017. Photo by Victor Boyko/Getty Images

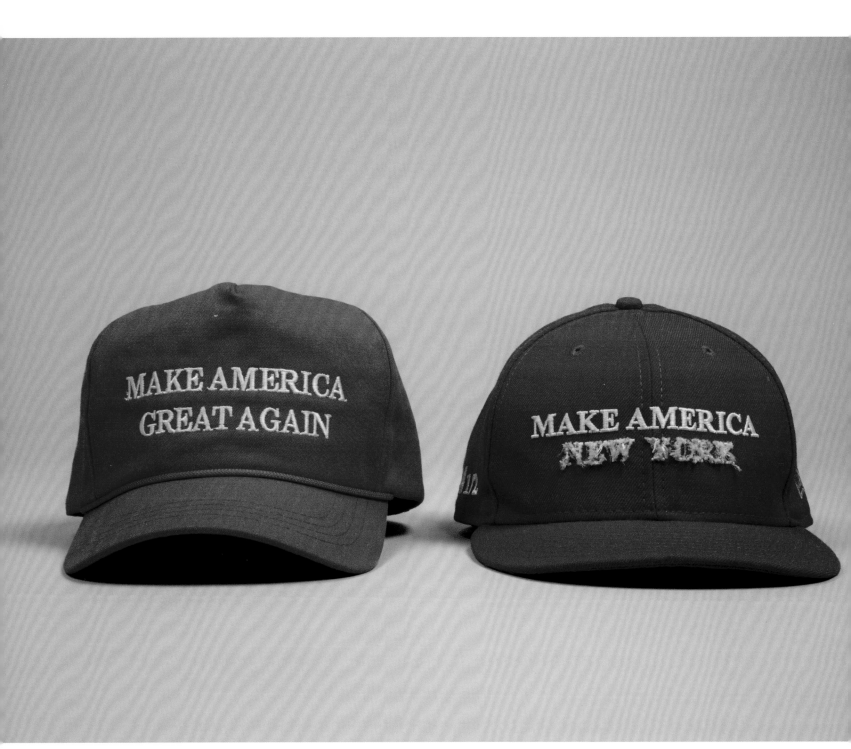

THE MAGA HAT VS. PUBLIC SCHOOL

Robin Givhan

The all-American baseball cap is one of the most banal mass appeal articles of clothing in existence. It's unisex and ageless, worn by people of all ethnicities, sexual orientations and races. It's one-size fits all. It doesn't matter if you're short or tall, skinny or fat. My baseball cap will fit you. Yours will fit me. Baseball caps unite us.

They are also freighted—burdened with meaning. They are a symbol of our patriotism— right alongside mom and apple pie. Baseball caps are democratic.

But their universality is precarious. The baseball cap is also a blank slate awaiting a message. It's a personal story waiting to be written. Its crown begs for an inscription: a team logo, a catch phrase, a tribal marking.

The "Make America Great Again" baseball cap was born during the 2016 presidential campaign. In its infancy, it was a benign slogan embraced by then-candidate Donald Trump. It was generally, initially, read as old-fashioned patriotism scrawled in white on a bright red cap. What did it signify? A couple of chickens in every pot, white picket fences, front doors left unlocked at night, families thriving just with dad's income from down at the plant.

But the hat and its phrase quickly became inflammatory as Trump's campaign unfolded and his (mostly) white supporters began their strident chants about building walls. The "again" portion soon appeared to champion the revival of an America over which white men unilaterally ruled, women kept the home fires burning, minorities knew their place, and LGBTQ was just a bunch of letters in the alphabet.

By the time Trump won the election, the slogan had been condensed into a hashtag —MAGA—and it became a governing philosophy of isolationism, nationalism, trade wars, and threats of closed borders. Soon enough, just the sight of a red MAGA hat was a rallying cry, fighting words, red meat patriotism.

The MAGA hat became a roaring fire that is occasionally tamped down to its embers but never goes out. And by 2019, any old red baseball cap was enough to make some folks do a double take. Is it? No. Ah, okay then.

In 2017, designers Maxwell Osborne and Dao-Yi Chow of the New York-based sportswear brand Public School tried to take back the red baseball cap. They tried to defang MAGA by offering an alternative message: Make America New York. On their runway, the cap's *New York* looked like a last minute act of subversion, as if someone had grabbed a MAGA hat, pulled apart its slogan with a sharp seam ripper and done a bit of hasty re-stitching. *New York* had the look of a do-it-yourself protest. A grassroots uprising against angry populism.

Applause for the intent. But the message?

America has always wanted to be *great*—whatever that fuzzy, imprecise word may mean. But it has never wanted to be New York. Only New Yorkers think everyone else wishes they were them. America has never wanted to become an urban village with cement canyons, mountains of black trash bags, and roaring subway trains. The American Dream is not to feel small in a big city or to disappear into a crowd. It is not to be lost in a sea of languages and unfamiliar faces while battling the fear of looking naïve or foolish.

No. Small-town America doesn't want to be the East Village or Williamsburg or Jackson Heights. It does not want to feel unhip, fat, or too earnest. America-at-large does not want to feel claustrophobic in studio apartments, on crowded sidewalks, or in restaurants where patrons sit cheek to jowl.

◀ "Make America Great Again" campaign hat, red cotton, 2017, USA, The Museum at FIT, 2018.45.1, Anonymous Donor. Public School by Maxwell Osborne and Dao-Yi Chow, "Make America New York" hat, red cotton, 2017, USA, The Museum at FIT, 2018.37.1, Gift of Public School

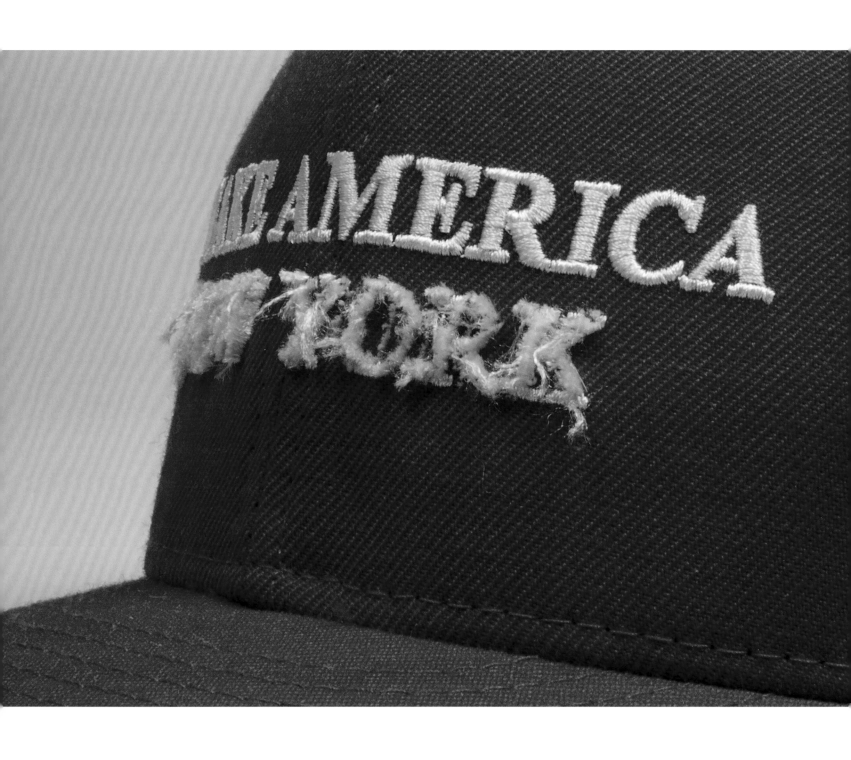

▲ Detail of "Make America New York," 2017 (see p. 92)

MAGA—the critics say—speaks of the singular privilege of having been born white and male in America. The counterbalance is not New York—a beautiful mosaic but one that is afflicted by de facto sophisticates who look at the denizens of flyover country with, at best, sympathy and at worst, condescension. America cannot, should not, be New York.

New York, for all its hubris and confidence, is only a small part of America. New York is niche. New York is a different kind of privilege.

America does not have to be remade into New York because it already *is* New York.

The citizens of Manhattan are real Americans, contrary to the political jargon that has all the real folks somewhere west of the Mississippi and east of the Rockies. New York is America at its most diverse and creative, striving and determined. But the city is also filled with the same American-ness of Iowa. It is rich with patriots and hard-workers, innocent children and wise seniors, independent thinkers and salt-of-the-earth neighbors. Both places host Fourth of July celebrations. Church bells toll in Midtown. And folks say Merry Christmas in Rockefeller Center.

There is a conceptual problem with both hats. The problems are not equal in magnitude. The Public School hat is no propaganda match for the MAGA one. Public School is championing diversity. MAGA is proposing a specious form of nostalgia.

America's greatness does not have to be remade. The country's excellence wasn't predicated on some stone monument that has crumbled over time. The country is not static. It's ever changing so that there is room for *everyone*'s dream. Life out there in the hinterland moves along, perhaps slower—but by whose standard?

Underneath the slogans, the team affiliations, and the tribal markings, there are two hats. Worn and damaged.

But still, one-size fits all.

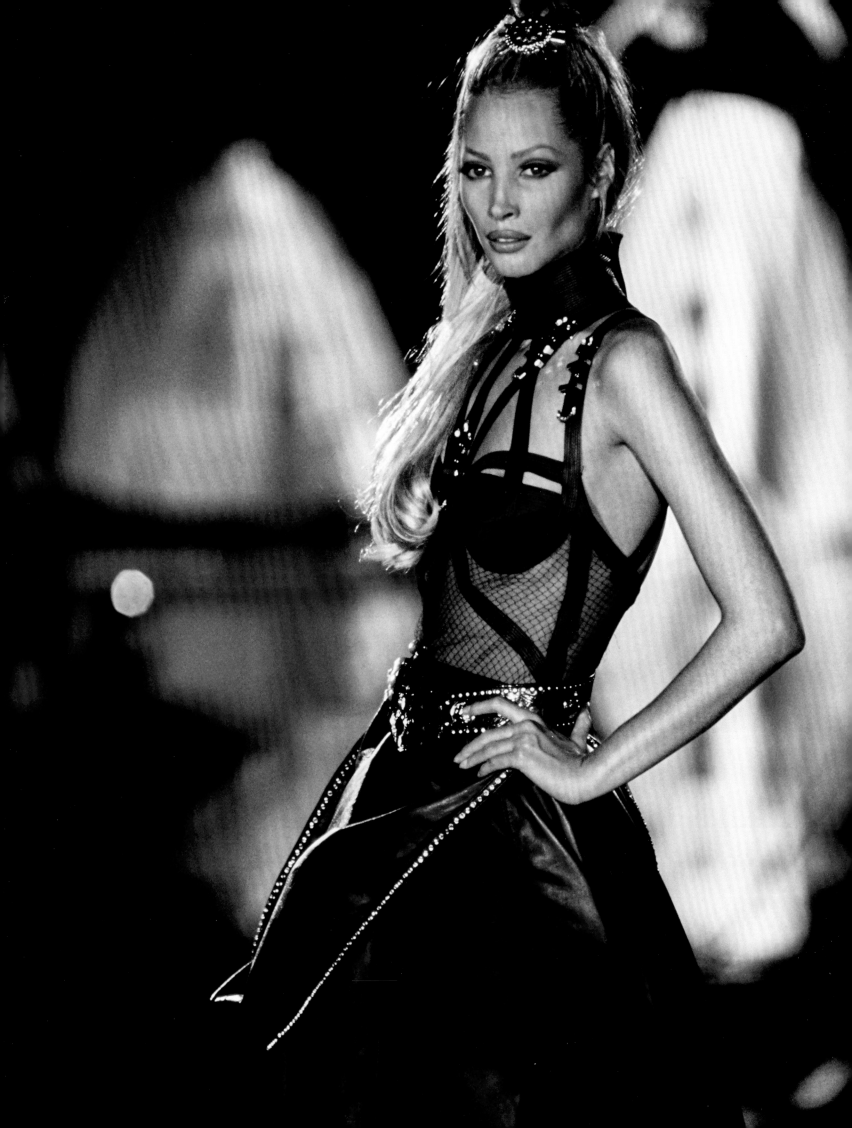

CHAPTER 5

SHEATHED IN SEX

Emma McClendon

In early 2005, then-Secretary-of-State Condoleezza Rice greeted U.S. troops at an army airfield in Wiesbaden, Germany, clad in a long, black, military-inspired coat and tall, black leather boots that pitched her up on narrow stiletto heels. Fashion critic Robin Givhan noted that Rice's sartorial style "eschewed the typical fare chosen by powerful American women on the world stage. She was not wearing a bland suit with a loose-fitting skirt and short boxy jacket with a pair of sensible pumps." Instead, "Rice's coat and boots speak of sex and power." She struck a "menacing silhouette" that recalled both the costumes of *The Matrix* and the fetishistic archetype of the dominatrix. She was "draped in a banner of authority, power and toughness . . . and that included her sexuality."[1]

There are many fashion objects and materials that have become culturally coded as "sexy." Corsets, leather, lingerie, rubber, and, of course, tall, high-heeled boots are but a few of the most obvious examples. While many "sexy" clothes have origins in the fetish community, the integration of these pieces into fashionable wardrobes, as well as popular culture in general, has become commonplace. As Valerie Steele has pointed out, "Today sexual 'perversity' sells everything from films and fashions to chocolates and leather briefcases."[2]

In her extensive work on fashion, fetish, and eroticism, Steele acknowledges the inherent complexity of the "power" associated with "sexy" garments. Their "sexiness" is usually interpreted through the heteronormative lens of the male gaze—a woman wears clothes that sexualize her body for male onlookers. Feminists critique this style of fashion as an overt objectification of women on the part of designers—striping the wearer of her power. However, as Steele observes, "Many women wear clothing with fetishistic association," and "It is likely . . . that the sex-and-power 'bad girl' image is part of the appeal of fetish fashion for women."[3] Women choose what they wear and it would be simplistic to think their choices are solely governed by the whims of men and dominating designers. In the donning of sexy clothing, women are often not just dressing to be seen, but to take on a "powerful" persona, such as Steele's "bad girl"—a woman in control of her sexuality. This is the duality of "sexy" fashion. It is "very much about power and perception,"[4] to use Steele's words. It is a delicate balancing act between dominance and subjugation, and how a look is interpreted depends on the interpreter (both wearer and observer).

There are two schools of thought on the power dynamics of sex, which Steele discusses in great depth in her books *Fetish* and *Fashion and Eroticism*. One view, laid out by Freud and the field of psychoanalysis, contends that centuries of Judeo-Christian morality have suppressed our collective sexuality, exemplified in the "repressed" attitude of the Victorian era. According to this view, a person comes to know him/herself by examining and understanding his/her "sexual identity." From this school of thought comes the popular belief that "owning" your sexual identity and being in control of your sexuality is a power statement of personal freedom and agency.

The second, opposing outlook comes from Michel Foucault, who believed that sex, or more accurately, our cultural understanding of sexuality, is actually another social mechanism that controls our bodies and minds rather than liberating them. For him, the Victorian era was hyper-sexualized and established the mode of thought that placed sexuality at the center of a person's identity. "Sexuality" here is dominating force—another "discipline" like those of the military and prison that regulates and manages bodies. Although those involved in the Sexual Revolution of the 1960s and 1970s believed openly embracing their sexuality freed them from the oppressive

◀ Christy Turlington in a look from Versace's 1992 "bondage" collection, April 1, 1992. Photo by Guy Marineau/Condé Nast via Getty Images

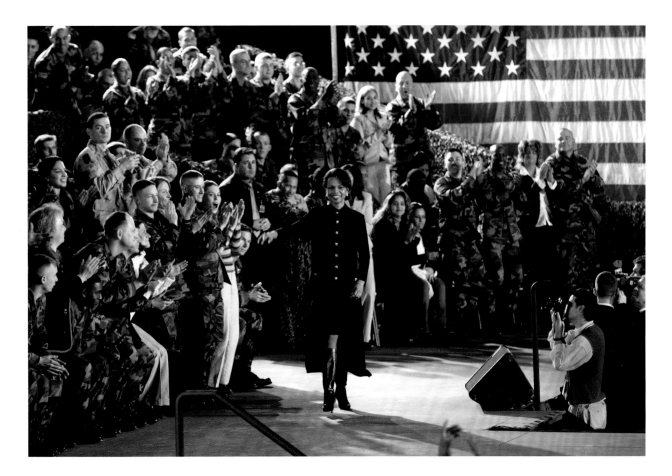

weight of normative society, according to Foucault, they were in fact acting within the dialectic of sexuality, power, and identity already established a century before.[5]

Most fashion designs of the last sixty years have embraced the former view of sex and power. Gianni Versace, for example, said of his famous 1992 bondage collection that "women today are strong . . . none of these girls are for sale,"[6] suggesting a link between his overtly sexual designs and the wearer's physical, social, and psychological power—by wearing his leather bondage look, she shows she is an independent, strong woman, not an object to be "owned."

This "strong" feeling clearly translated to the women who actually wore the Versace bondage look. A *New York Times* article from 1992 quoted Elizabeth Tilberis, then-editor-in-chief of *Harper's Bazaar*, as saying that "her studded black leather Versace made her feel 'like this'. . . [as] she struck a boxing pose."[7] Indeed, the *feel* of "sexy" clothes is often as significant for the wearer as the look. The feeling of walking in high heels, of tight leather against the skin, is often referenced by wearers as part of what makes them feel "powerful" in these pieces. With such culturally potent fashion symbols, the physical sensation helps the wearer take on the "persona" of the object.

But the same *New York Times* article also notes that there was a feminist outcry against the Versace collection. It quotes *New Yorker* fashion critic Holly Brubach saying that "mostly women could barely evaluate the design aspect of it because we were so offended. I have to say that I hated it."[8] According to critics, Versace's bound women were anything but independent and strong. They were "harnessed" and objectified for male consumption. In part this was because of how literal many of the fetish "adaptations" were. Whereas Brubach saw Jean Paul Gaultier's leather work as "humorous" and Claude Montana's "leather ice queens" as chic, "Versace's designs, more than anyone else's, suggest specific sexual practices. They strike me as needing equipment."[9]

It is worth noting that Versace did not create these overtly sexual designs for just women— his menswear also drew heavily on fetish influences, including leather and bondage. Here again is the duality Steele recognized in the reception and interpretation of erotic fashion. The power dynamic of a garment (or collection) is about perception and power, and it does not have a fixed

◀ Secretary of State Condoleezza Rice at Wiesbaden U.S. Army Base in Germany, February 23, 2005. Photo by REUTERS/Kevin Lamarque

meaning. As Brubach herself admitted, "Versace riles women who think this is exploitative and appeals to women who think of his dominatrix look as a great Amazonian statement. It could go either way."[10]

Many of today's most recognizably "sexy" garments first found their way into mainstream popular culture during the Sexual Revolution of the 1960s and 1970s. Steele cites the example of Diana Rigg's character Emma Peel on the British TV series *The Avengers*. Her PVC and leather catsuits and matching boots paved the way for Claude Montana's leather-clad "power" women of the 1980s.[11] Likewise, the increased visibility of the "leather man" look through Gay Pride parades and The Village People during the 1970s and 1980s helped set the stage for Versace's bondage look to take over high fashion during the 1990s.

Street styles have also been important to the spread of erotic fashion. The British punks that emerged in London during the 1970s adopted overtly "taboo" fetish clothing to visually convey their disdain for the "prim" and "proper" norms of "polite" British society. Rubber fetish gear, studded leather jackets and pants, dog collars, and body piercings were some of the most prevalent fetish elements of punk style for both genders.

Designer Vivienne Westwood and her then-husband Malcolm McLaren personified the punk look. McLaren acted it out on stage in performances with his band Sex Pistols while Westwood provided the garments themselves in her Kings Road boutique, which she renamed "SEX" in 1974. Inside, she sold rubber fetish suits, bondage, and SM gear alongside slashed T-shirts. Steele noted, "The clients were about half fetishists (who had expensive rubber suits custom made) and half young people who wanted clothes that were about 'breaking taboos' and making 'a statement about how BAD you are.'"[12]

Since the days of Westwood's fetishistic punk look and Versace's bondage collection, high fashion designers have consistently engaged in overt references to fetish wear. Alexander McQueen, John Galliano, and Riccardo Tisci are but a few of the most prominent designers who often drew on the styles and materials of erotica to imbue their collections with both sex and power. Today, Shayne Oliver of Hood by Air continues this legacy, combining street style, fetish gear, and references to pornography to create collections that challenge normative views of gender as well as sexuality. The visual vocabulary of sex becomes a power statement on the fluidity of gender identity in the twenty-first century.

▶ Chanel by Karl Lagerfeld, shoes, black silk, plastic, metal, cruise 2009, France, The Museum at FIT, 2012.63.1, Gift of CHANEL

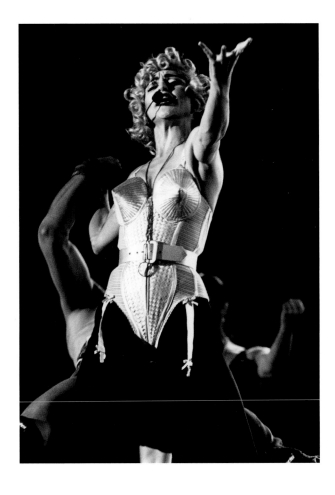

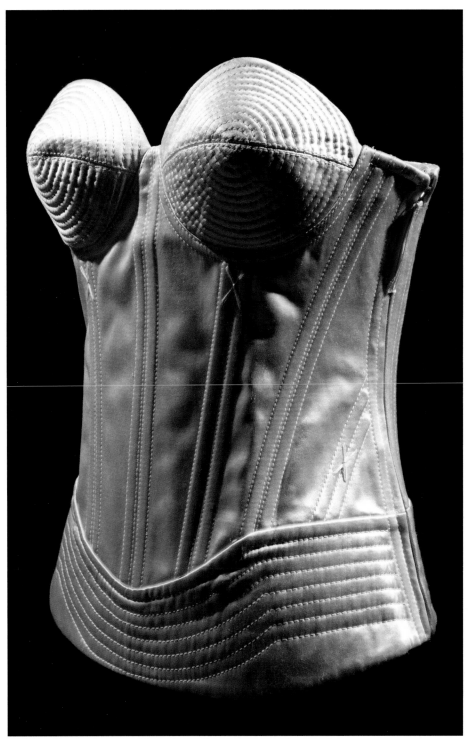

◀ Corset, red wool, silk, steel, whalebone, c. 1880, France (possibly), The Museum at FIT, 98.29.3, Museum purchase

During the nineteenth century, the corset was a necessary component of fashionable dressing. Since then, it has been appropriated by the fetish community, where Valerie Steele notes it is worn by both the dominant and the submissive. "The corseted dominatrix looks and feels 'impenetrable.'" In contrast, the submissive wears a corset to signal "discipline" and "bondage."[1]

▶ Jean Paul Gaultier, corset top, pink satin, fall 2010, France, The Museum at FIT, 2017.61.1, Museum purchase

Jean Paul Gaultier was a pioneer of underwear as outerwear, adapting lingerie into erotic ready-to-wear for the runway. This bustier is a prime example. Shown in 2010, it recalls the famous cone bra costumes he designed for Madonna's Blonde Ambition Tour in 1990.

▲ Madonna performing during her Blonde Ambition Tour wearing one of her famous "cone-bra" costumes designed by Jean Paul Gaultier, July 16, 1990. Photo by INTERFOTO/Alamy Stock Photo

◀ Christian Dior by John Galliano,
dress, black leather, 2000,
France, The Museum at FIT,
2001.45.1, Museum purchase

*Galliano combines black
leather with lacing to create
an erotic cocktail dress.
The look recalls the leather
suits and corsets of fetish
wear, but here they have
been deconstructed and
draped across the body
asymmetrically. This gives
the wearer an air of being
caught in the midst of
undressing.*

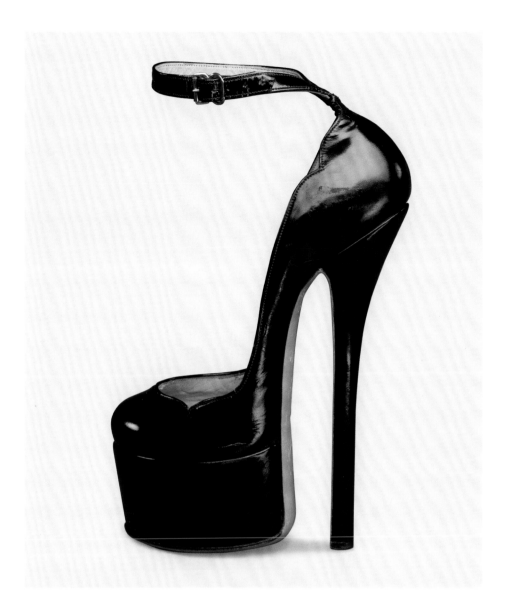

▲ Fetish shoes, black patent leather, c. 1973–75, Mexico, The Museum at FIT, P91.25.2, Museum purchase

This fetish shoe has an extremely long, narrow heel that would be near-impossible to walk on. There is often considered to be a correlation between heel height and erotic appeal. Rendered in shiny patent leather with a high platform and ankle strap, this shoe was primarily designed to be seen and handled.

▶ Chanel by Karl Lagerfeld, shoes, black silk, plastic, metal, cruise 2009, France, The Museum at FIT, 2012.63.1, Gift of CHANEL

Karl Lagerfeld takes the distinctive silhouette of the fetish shoe, but replaces the stiletto heel with a gun. It is immediately evocative of sex, violence, and power—a visual metaphor for the "femme fatale."

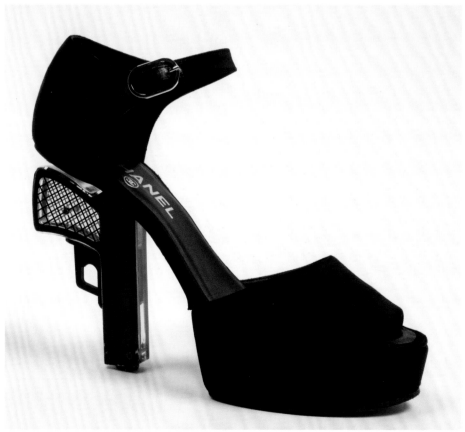

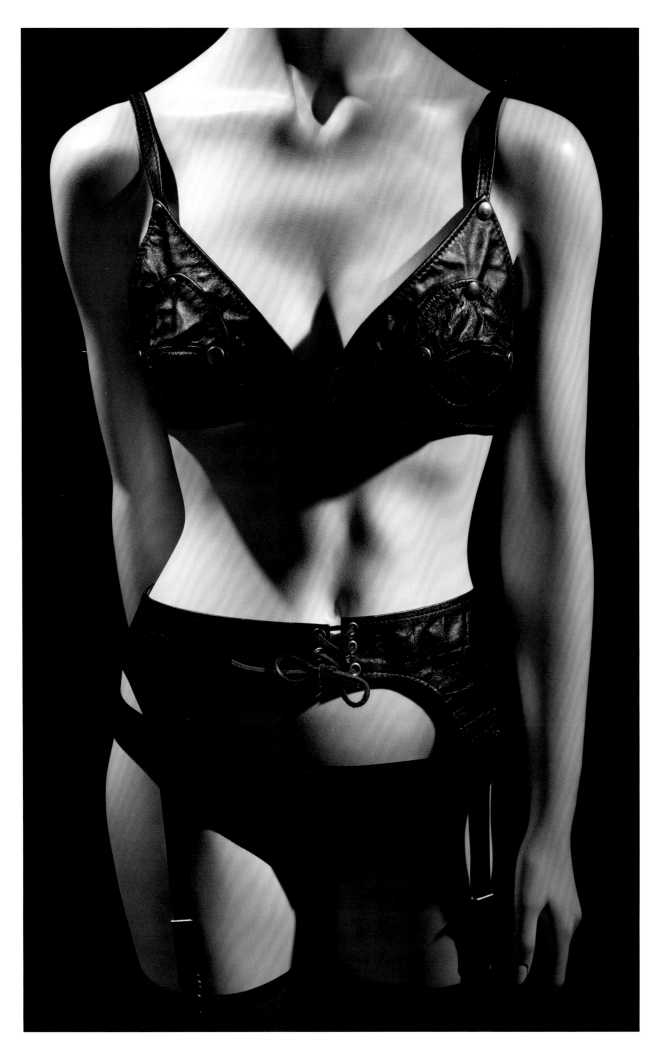

◀ Fetish ensemble, black leather and metal, 1982, USA, The Museum at FIT, P83.12.2, Museum purchase

Leather is a key material for fetish wear. It is sensuous with a distinctive feel, look, and smell—an erotic second skin. Considered a "hard" material (as opposed to softer silks, lace, and fur), leather is often associated with dominance and S&M subculture.

▶ Seditionaries by Vivienne Westwood and Malcolm McLaren, shirt, white cotton and plastic rings, c. 1978, England, The Museum at FIT, 98.140.2, Museum purchase

This shirt incorporates bondage straps and cock-rings around the chest, a nod to the S&M subculture as appropriated by the punk movement. Made in soft cotton instead of the typical black leather of fetish wear, the shirt is a twist on the traditional white button up.

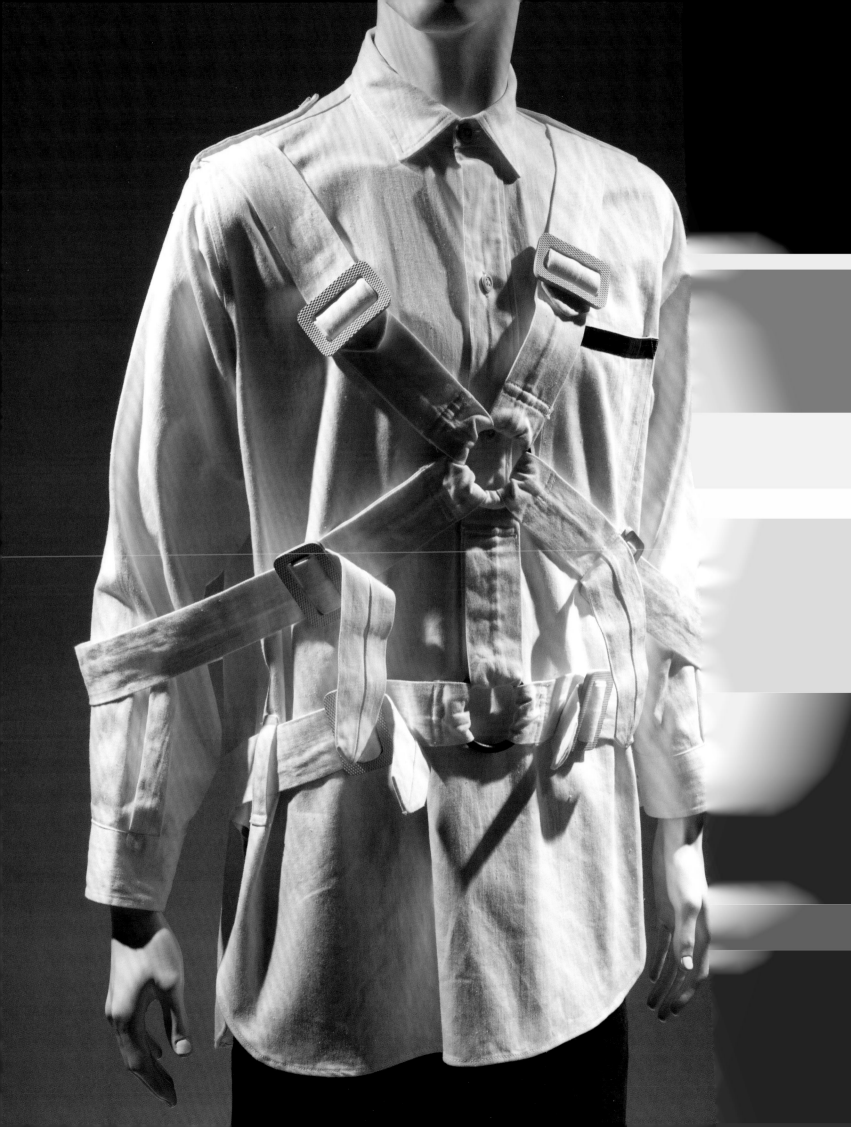

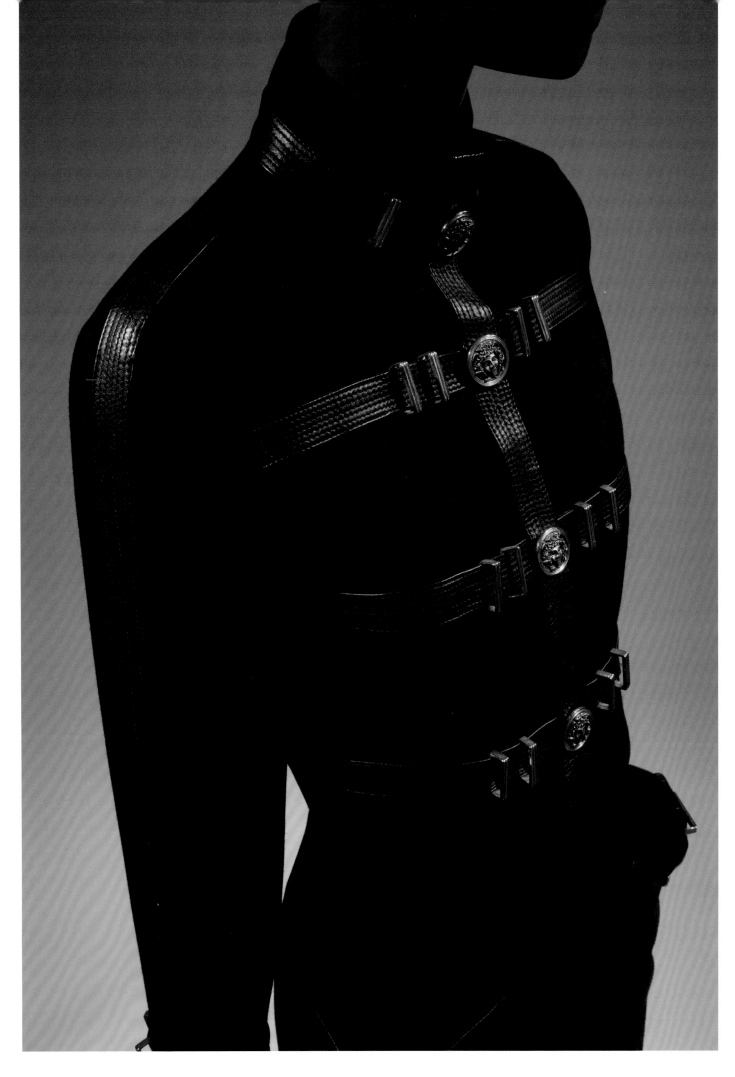

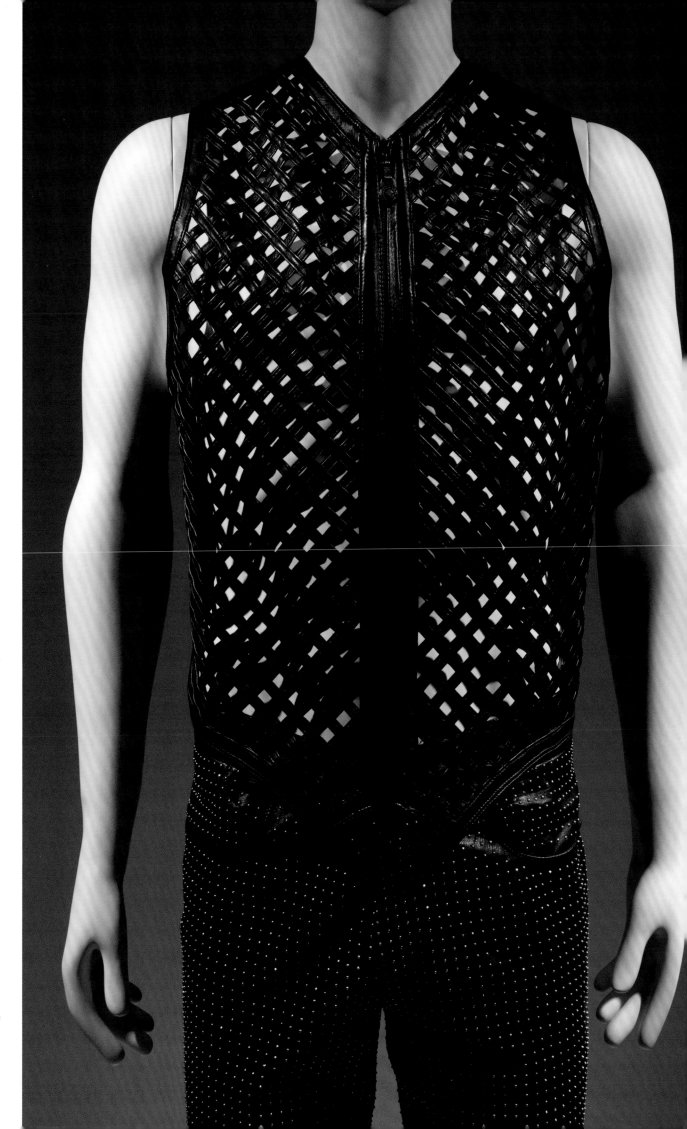

◀ Gianni Versace, suit, black wool, leather, metal, 1992, Italy, The Museum at FIT, 98.20.5, Gift of Judith Corrente & Willem Kooyker

This suit from Versace's 1992 "bondage" collection straps the wearer in with a series of leather and metal buckles, each adorned with the brand's distinctive Medusa logo. Medusa—a mythological woman transformed into a monster as punishment for her lustful actions—is an apt heroine for Versace's sexually "strong woman."

▶ Gianni Versace, man's vest and pants, black leather and metal, spring 1993, Italy, The Museum at FIT, 2005.40.4 and 2005.40.5, Gift of Michael Sherman

A year after his famous "bondage" womenswear collection, Versace designed these leather garments for his menswear collection. The studded pants and perforated vest are a direct reference to Leatherman subculture. Versace was known for incorporating overt homoerotic references into his menswear designs.

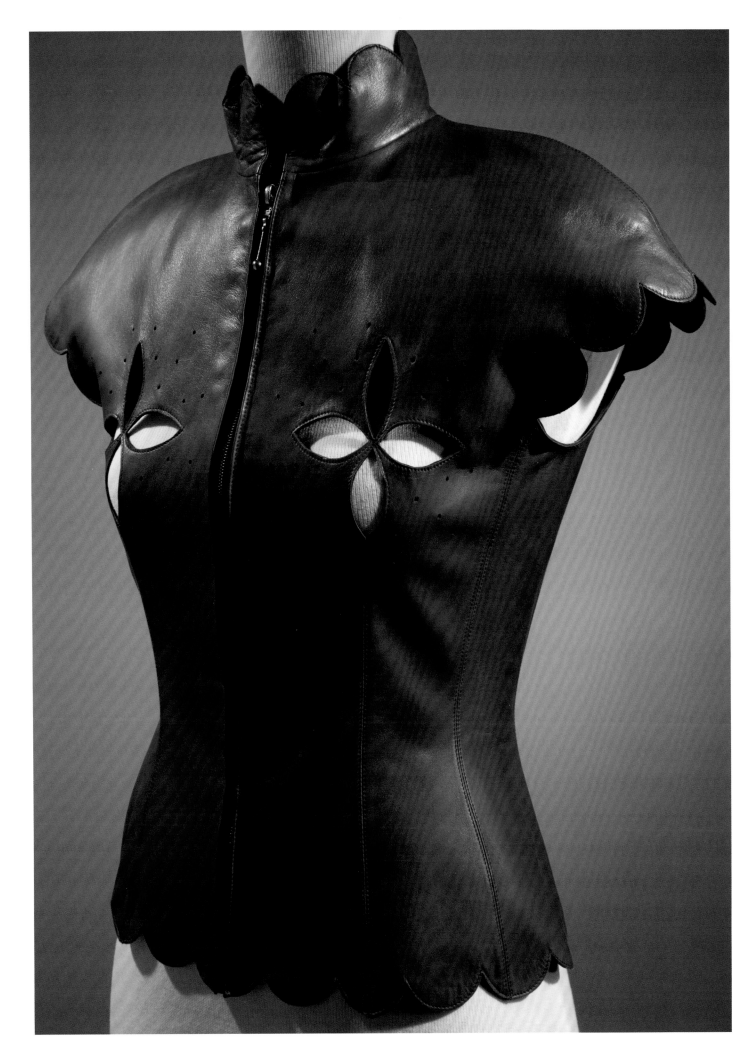

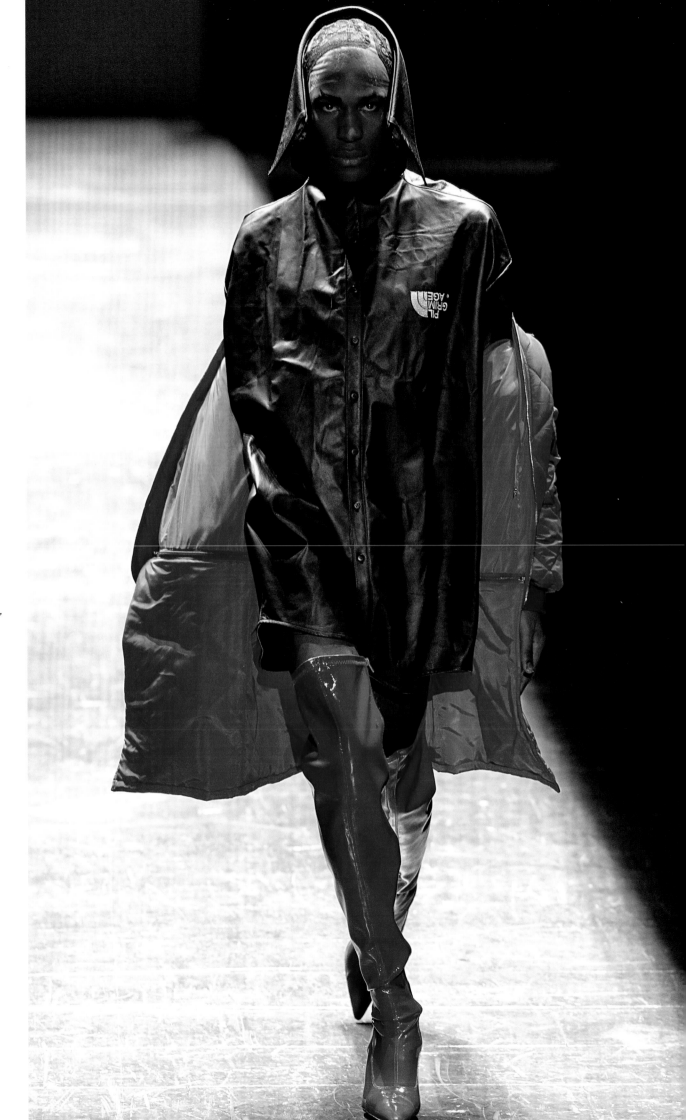

◀ Givenchy by Alexander McQueen, top, purple leather, fall 1997, France, The Museum at FIT, 98.51.1, Gift of Givenchy Couture

Alexander McQueen showed this top as part of his fall 1997 collection for Givenchy. On its own, the leather and nipple cut-outs clearly draw inspiration from fetish wear. But for the runway, McQueen dressed the top with a black turtleneck underneath and completed the look with black wool pants and heels for the more conservative Givenchy clientele.

▶ Hood by Air by Shayne Oliver, unisex ensemble, black and red nylon, leather, plastic, fall 2016, USA, The Museum at FIT, 2016.87.1, Gift of Hood by Air

This unisex Hood by Air ensemble draws inspiration from fetish wear to challenge the sartorial norms of gender identity. It pairs thigh-high, stiletto boots with a puffer coat and oversized man's shirt. But the black leather shirt becomes a daring mini-dress as the collar extends over the wearer's head to form a hood.

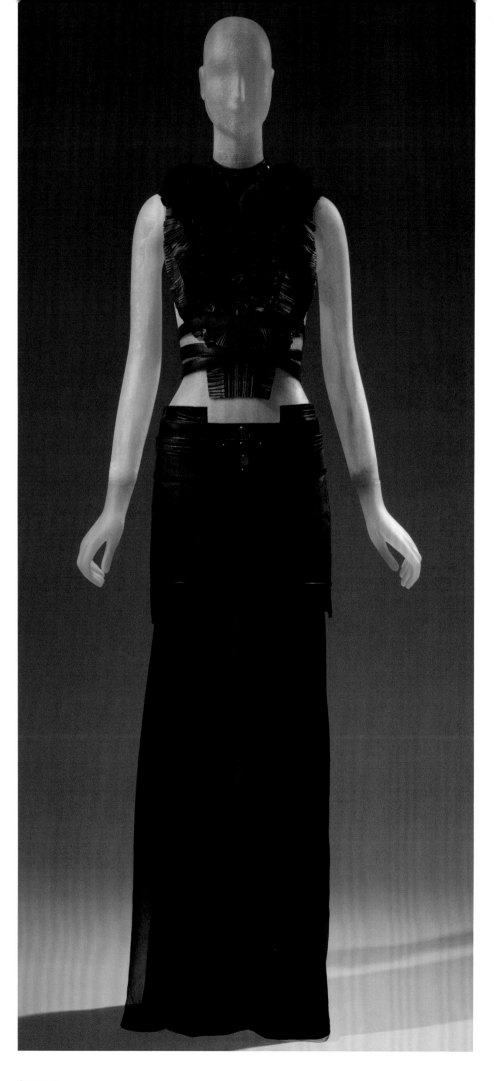

◀ Givenchy by Riccardo Tisci,
ensemble, black leather, silk
chiffon, metal, spring 2011,
France, The Museum at FIT,
2011.8.1, Gift of Givenchy
by Riccardo Tisci

*This ensemble by Riccardo
Tisci for Givenchy includes an
elaborate leather harness top.
Inspired by bondage wear,
the look is an update on
the erotic fetish looks
Alexander McQueen created
for Givenchy more than ten
years earlier. Tisci's work for
the house became known for its
erotic and gothic sensibility.*

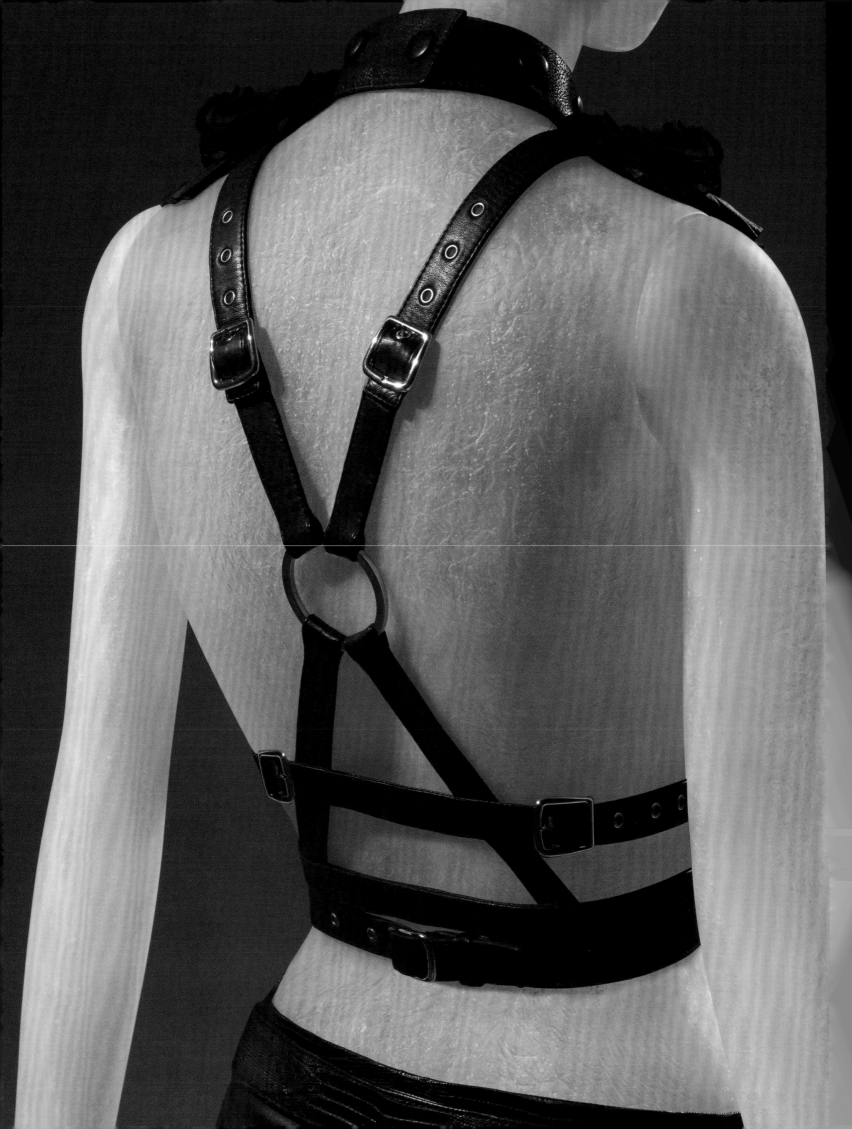

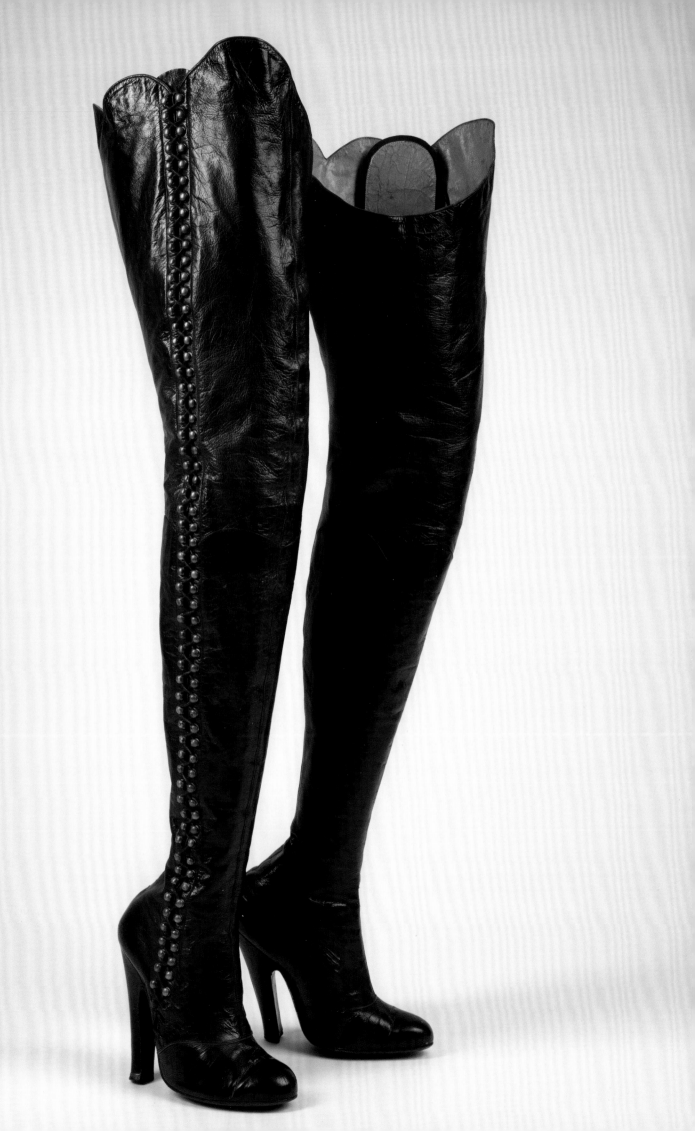

A PAIR OF FETISH BOOTS

Valerie Steele

Traditionally, feminist discourse has assumed that fashion disempowers women, both through a general emphasis on conformity to fashionable beauty standards and also specifically, by encouraging women to wear garments that are physically restrictive and/or overtly sexualizing. High-heeled shoes are often given as a prime example of "bad" fashion. On the other hand, many women say that high-heeled shoes can *feel* empowering, because they make the wearer taller or enhance self-confidence. It has also been suggested that "sexy" high heels augment female "sexual power," although this argument is controversial. Individual women have certainly gained power by using their sexuality to manipulate powerful men, but the so-called Eva Perón phenomenon has done little or nothing to empower women in general.[1]

Cross-culturally, power is overwhelmingly wielded by men, where it is usually defined in terms of socio-economic and political-religious power, as well as physical and military force. Business suits, royal regalia, and military uniforms are types of clothing associated with predominantly male power. Despite women's relative lack of power in society, many men seem to feel that women are—or can be—frighteningly, sometimes alluringly, powerful. Fear of female (maternal?) power appears to be one of the main sources of patriarchal attempts to control women's sexuality. Yet according to many psychiatrists, the commonest male sexual fantasy focuses on the image of a powerful and aggressively sexual "phallic woman," whose appearance has traditionally been marked by iconic fetish styles, such as high-heeled shoes and boots.[2]

This pair of fetish boots, dating from about 1930, is a rare and fine example of the specialized fetish wear that has existed at least since the later nineteenth century. A leather label on the interior of the boot identifies the maker as Diana Slip, a French manufacturer of specialist lingerie and fetish wear, with a boutique at 9 Rue Richepanse, Paris-Madeleine. Diana Slip was established in the 1920s by Léon Vidal, who also owned Les Éditions Gauloises, an erotica publisher and distributor. Fetish wear was a prominent feature in pornographic films and photographs, and Vidal hired well-known photographers, such as Brassaï and Roger Schall, to promote his products. His main competitor in Paris was Yva Richard.[3]

The heels on this pair of fetish boots are 5 inches, and the boots themselves are thigh-high, a style that tends to be regarded as significantly more erotic than ankle boots or boots that extend only up to the knee. Very similar boots are depicted in photographs in the collection of the Kinsey Institute. Although 5-inch heels are relatively high for ordinary fashionable shoes today, they are modest for contemporary fetish shoes, indicating that, in both the fetish and fashion worlds, high heels have become higher since the 1930s. The height of these boots and the heel-toe proximity would have made walking in them very difficult. Nevertheless, they would have made the wearer look powerful, since, already by the 1920s, high-heeled boots were associated with the figure of the dominatrix.[4]

Made of black leather, a second-skin material that is associated with both sexual fetishism and sadomasochism, this pair of boots is about a woman's size 5, much too small for a male cross-dresser. They were probably worn by a dominatrix or other sex worker. There is red leather trim at the front vamp seam, heel, and along the scalloped edge of the wide openings at top. Black and red were and remain the two most popular colors for fetish fashion, in part because of their associations with evil, the devil, and the flames of hell.

It is probable that 5-inch heels and thigh-high boots are phallic symbols in the fetishistic imaginary, but there are additional reasons for the boots' erotic allure. Like a corset, the boots

◀ Diana Slip, fetish boots, black leather, brass, cotton, c. 1930, France, The Museum at FIT, 2013.50.1, Museum purchase

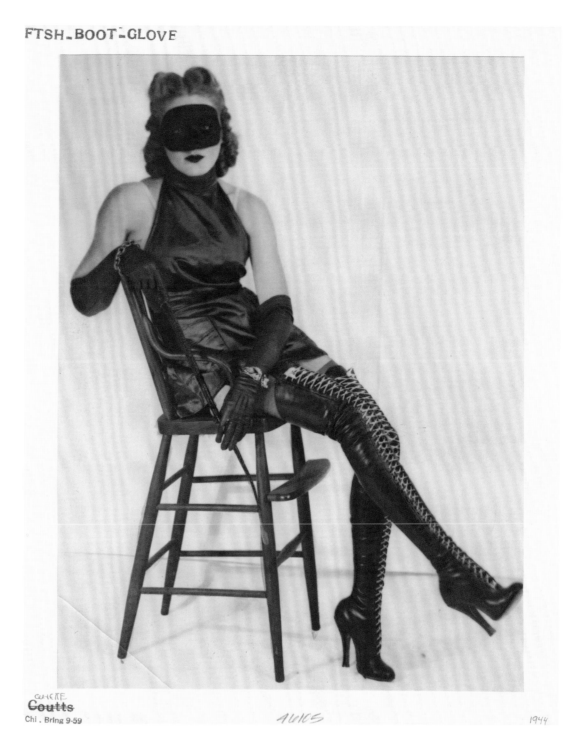

Coutts
Chi . Bring 9-59 ALICS 1944

lace up the sides with 118 brass hooks and black cotton cord laces. Lacing the boots would have been a type of ritual adornment of the wearer's body. When fully laced, each boot creates the silhouette of a human leg, a body part that, like the foot, is frequently fetishized.

Although the Musée International de la Chaussure owns several fetish shoes and boots, they are rare. This particular pair of boots is also an exceptionally fine example of the craft of shoe-making. Significantly, fetish boots like these have influenced the design of fashionable footwear. As early as the 1960s, so-called "kinky boots" were featured in fashion magazines, and by the 1990s, high-fashion designers were creating deliberately fetishistic styles.

◀ Detail with label of Diana Slip's feitsh boots, c. 1930 (see p. 112)

▶ *Fetish Fashion*, c. 1944, Kinsey Institute

NOTES

Introduction

[1] Matthew Schneier, "In the N.B.A. a Games of Clothes Horse," in *The New York Times* (April 20, 2018), accessed May 25, 2019 <https://www.nytimes.com/2018/04/20/style/cleveland-cavaliers-lebron-james-thom-browne-.html.>

[2] Vanessa Friedman, "The Mess of Modern Power Dressing," in *The New York Times* (March 14, 2019), accessed May 25, 2019 <https://www.nytimes.com/2019/03/14/fashion/the-mess-of-modern-power-dressing.html?rref=collection%2Fbyline%2Fvanessa-friedman>

[3] Steven Lukes, *Power: A Radical View*, second edition (New York: Palgrave MacMillan, 2005), 61.

[4] Thomas Hobbes in Lukes, 66.

[5] Max Weber in Lukes, 76.

[6] Robert Dahl in Lukes, 16.

[7] Lukes, 59.

[8] Ibid., 25.

[9] Ibid., 109.

[10] Pierre Bourdieu, *Distinction: A Social Critique of the Judgement of Taste*, transl. Richard Nice (Cambridge, Massachusetts: Harvard University Press, 1984), 169–225.

[11] See Daniel Miller, *Material Culture and Mass Consumption* (Oxford, UK: Basil Blackwell, 1987); Daniel Miller, *Stuff* (Cambridge, UK: Polity Press, 2010).

[12] Bourdieu, 468.

[13] Michel Foucault in Lukes, 89.

[14] Lukes, 12.

[15] James Scott in Lukes, 124–25.

[16] James Scott in Lukes, 125.

[17] See Erica Chenoweth and Maria J. Stephan, *Why Civil Resistance Works: The Strategic Logic of Nonviolent Conflict* (New York: Columbia University Press, 2011).

[18] Bourdieu, 200.

[19] Anne Hollander, *Sex and Suits: The Evolution of Modern Dress* (New York: Alfred A. Knopf, 1994), 5.

[20] Lukes, 65.

[21] Fred Davis, *Fashion, Culture, and Identity* (Chicago: University of Chicago Press, 1992), 8.

[22] Thorstein Veblen, *The Theory of the Leisure Class* (New York: MacMillan Company, 1899).

[23] Rebecca Arnold, *Fashion, Desire and Anxiety: Image Morality in the 20th Century* (New Brunswick, New Jersey: Rutgers University Press, 2001), 12.

[24] Ibid., 13.

[25] Peter Morriss, *Power: A Philosophical Analysis* (Manchester, UK: Manchester University Press, 2002).

[26] Valerie Steele, *Fetish: Fashion, Sex and Power* (New York: Oxford University Press, 1996), 11–55.

[27] Scott in Lukes, 128.

[28] Gilles Lipovetsky, *The Empire of Fashion: Dressing Modern Democracy*, transl. Catherine Porter (Princeton, New Jersey: Princeton University Press, 1994), 5.

[29] Lisa Trivedi, *Clothing Gandhi's Nation: Homespun and Modern India* (Bloomington, Indiana: Indiana University Press, 2007).

Chapter 1

Dressed for Battle

[1] Daniel Roche in Jennifer Craik, *Uniforms Exposed: From Conformity to Transgression* (New York: Berg, 2005), 29.

[2] Craik, 33.

[3] See Jennifer Craik's use of the word "glamour"and its importance to understanding military uniforms in Craik, 34.

[4] Stefano Tonchi in *Uniform: Order and Disorder*, ed. by Francesco Bonami, Maria Luisa Frisa, and Stefano Tonchi (Milan: Charta, 2000), 155.

[5] Craik, 24.

[6] Michel Foucault, *Discipline and Punish: The Birth of the Prison*, transl. Alan Sheridan (New York: Vintage Books, Random House, 1977), 135.

[7] Lorenzo Greco in *Uniform: Order and Disorder*, 148.

[8] Ibid., 147.

[9] Ibid., 147 and 150.

[10] Ibid., 150.

[11] Foucault, 135.

[12] Craik, 29

[13] Tonchi in *Uniform: Order and Disorder*, 157

[14] Craik, 182.

Chapter 2

Suited Up

[1] Robert Dahl in Steven Lukes, *Power: A Radical View*, second edition (New York: Palgrave MacMillan, 2005), 16.

[2] *Bob's Burgers*, "O.T. the Outside Toilet," season 3, episode 15. First aired on FOX, March 3, 2013.

[3] Anne Hollander, *Sex and Suits: The Evolution of Modern Dress* (New York: Alfred A. Knopf, 1994), 3.

[4] Christopher Breward, *The Suit: Form, Function & Style* (London: Reaktion Books, 2016), 10.

[5] Hollander, 84.

[6] Ibid., 90.

[7] Ibid., 90.

[8] Ibid., 79.

[9] Ibid., 79.

[10] Ibid., 3.

[11] G. Bruce Boyer, *True Style: The History & Principles of Classic Menswear* (New York: Basic Books, 2015), 29.

[12] Michel Foucault, *Discipline and Punish: The Birth of the Prison*, transl. Alan Sheridan (New York: Vintage Books, Random House, 1977), 233.

Quote on p. 48

[1] Lady Gaga quoted in Alanna Vagianos, "Lady Gaga Wears an Oversized Pantsuit for a Powerful, Feminist Reason," in *The Huffington Post* (October 16, 2018), accessed April 4, 2018 < https://www.huffpost.com/entry/lady-gaga-wears-an-oversized-pantsuit-for-a-powerful-feminist-reason_n_5bc62f76e4b055bc947ae788 >

Grace Wales Bonner

[1] https://walesbonner.net

[2] Alex Rayner, "Grace Wales Bonner: 'I'm a fashion designer making art—it could be seen as silly,'" in *The Guardian*, Art & Design, February 2, 2019.

Chapter 3

Status as Style

[1] G. Bruce Boyer, *True Style: The History & Principles of Classic Menswear* (New York: Basic Books, 2015), 25.

[2] Philippe Perrot, *Fashioning the Bourgeoisie: A History of Clothing in the Nineteenth Century*, transl. Richard Bienvenu (Princeton, New Jersey: Princeton University Press, 1994), 15.

[3] Peter McNeil and Giorgio Riello, *Luxury: A Rich History* (Oxford, UK: Oxford University Press, 2016), 229.

[4] Rebecca Arnold, *Fashion, Desire and Anxiety: Image Morality in the 20th Century* (New Brunswick, New Jersey: Rutgers University Press, 2001), 16.

[5] Perrot, 80.

[6] McNeil and Riello, 9.

[7] Perrot, 81.

[8] Ibid., 72.

[9] Thorstein Veblen, *The Theory of the Leisure Class* (New York: MacMillan Company, 1899), 68–101.

[10] Perrot, 82.

[11] Ibid., 86.

[12] Naomi Klein, *No Logo* (New York: Picador, 2000), 3.

[13] McNeil and Riello, 9.

[14] Lucy Handley, "The luxury sector is growing faster than many others and Gucci is in the lead," on cnbc.com (October 4, 2018), accessed May 2, 2019 < https://www.cnbc.com/2018/10/04/the-luxury-sector-is-growing-faster-than-many-others-and-gucci-leads.html>

Quote on p. 60
[1] Rebecca Arnold, *Fashion, Desire and Anxiety: Image Morality in the 20th Century*, (New Brunswick, New Jersey: Rutgers University Press, 2001), 16.

An Eighteenth-century Embroidered Suit
[1] Garrick to Jean-Baptiste Antoine Suard, August 21, 1770, in *The Letters of David Garrick*, ed. by David M. Little, George M. Kahrl, and Phoebe de K. Wilson (associate ed.) (Oxford: Oxford University Press, 1963), 708–9.

Chapter 4

Fashioning Resistance
[1] Jenny B. Fine, "Power to the People," in *WWD Beauty Insider* (April 2018), 60–63.
[2] Erica Chenoweth in Erica Cheonoweth and Kathleen Gallagher Cunningham, "Understanding nonviolent resistance: An introduction," in *Journal of Peace Research*, vol. 50, no. 3, special issue (May 2013), 271–76.
[3] Rebecca Arnold, *Fashion, Desire and Anxiety: Image Morality in the 20th Century*, (New Brunswick, New Jersey: Rutgers University Press, 2001), 12.

Quote on p. 90
[1] 911 caller quoted in Linton Weeks, "Tragedy Gives the Hoodie a Whole New Meaning," on *National Public Radio* (March 24, 2012), accessed May 2, 2018 < https://www.npr.org/2012/03/24/149245834/tragedy-gives-the-hoodie-a-whole-new-meaning >

Chapter 5

Sheathed in Sex
[1] Robin Givhan, "Condoleezza Rice's Commanding Clothes," in *The Washington Post* (February 25, 2005), accessed April 2, 2019 <https://www.washingtonpost.com/archive/lifestyle/2005/02/25/condoleezza-rices-commanding-clothes/e7dbedfe-4e60-4e37-a210-ed8733f29d0b/?utm_term=.01bbd4b19cd8>
[2] Valerie Steele, *Fetish: Fashion, Sex and Power* (New York: Oxford University Press, 1996), 9.
[3] Ibid., 44.
[4] Ibid., 5.
[5] Michel Foucault, *The History of Sexuality Volume 1: An Introduction*, transl. Robert Hurley (New York: Vintage Books, Random House, 1990), 147.
[6] Gianni Versace quoted in James Servin, "Chic Or Cruel?" in *The New York Times* (November 1, 1992), accessed on April 25, 2019 < https://www.nytimes.com/1992/11/01/style/chic-or-cruel.html >
[7] Elizabeth Tilberis quoted in Servin.
[8] Holly Brubach quoted in Servin.
[9] Ibid.
[10] Ibid.
[11] Steele, 34.
[12] Ibid., 37.

Quote on p. 101
[1] Valerie Steele, *Fetish: Fashion, Sex and Power* (New York: Oxford University Press, 1996), 63.

A Pair of Fetish Boots
[1] Elizabeth Wilson, *Adorned in Dreams: Fashion and Modernity* (London and New York: I. B. Taurus, 2003 [1985]), pp. 228–47; Valerie Steele, *Shoes: A Lexicon of Style* (New York: Rizzoli, 1999), 16–43; Lucy Collins, "Conversations on Power: Valerie Steele in conversation with Robin Givhan," in *Vestoj* (Autumn 2013): 16–17.
[2] Valerie Steele, *Fetish: Fashion, Sex, and Power* (Oxford and New York: Oxford University Press, 1996), 14–19, 168. See also Dominique and François Gaulme, *Power and Style: A World History of Politics and Dress* (Paris: Flammarion, 2012).
[3] There is a photograph of underpants by Diana Slip in Steele, *Fetish*, 121. See also Olivier Singer, "The Forgotten Fetishwear Company of 1920s Paris" <http://www.anothermag.com/fashion-beauty/8761/the-forgotten-fetishwear-company-of-twenties-Paris>. AnOther. Retrieved March 18, 2019; Karen Strike, "Vintage Bondage and Fetish Gear by Yva Richard and Diana Slip (NSFW)" <http://flashback.com/vintage-bondage-and-fetish-gear-by-yva-richard-and-diana-slip-nsfw-361517/>. Flashback. Retrieved March 18, 2019; Alexandre Dupouy, *Yva Richard: L'âge d'or du fétichisme* (Paris: Éditions Astarté, 1994).
[4] See Steele, *Fetish*, 10 for the photograph from the Kinsey Institute, and chapter 4: "Shoes," 91–114; Berkeley Kaite, *Pornography and Difference* (Bloomington and Indianapolis: Indiana University Press, 1995), chapter 4: "The Shoe," 91–112.

SELECT BIBLIOGRAPHY

• Arnold, Rebecca. *Fashion, Desire and Anxiety: Image Morality in the 20th Century*. New Brunswick, New Jersey: Rutgers University Press, 2001.

• Bonami, Francesco, Maria Luisa Frisa, and Stefano Tonchi (eds.). *Uniform: Order and Disorder*. Milan: Charta, 2000.

• Bourdieu, Pierre. *Distinction: A Social Critique of the Judgement of Taste*, transl. Richard Nice. Cambridge, Massachusetts: Harvard University Press, 1984.

• Boyer, G. Bruce. *True Style: The History & Principles of Classic Menswear*. New York: Basic Books, 2015.

• Breward, Christopher. *The Suit: Form, Function & Style*. London: Reaktion Books, 2016.

• Chenoweth, Erica and Kathleen Gallagher Cunningham. "Understanding nonviolent resistance: An introduction," in *Journal of Peace Research*, vol. 50, no. 3, special issue (May 2013), 271–76.

• Chenoweth, Erica and Maria J. Stephan. *Why Civil Resistance Works: The Strategic Logic of Nonviolent Conflict*. New York: Columbia University Press, 2011.

• Craik, Jennifer. *Uniforms Exposed: From Conformity to Transgression*. New York: Berg, 2005.

• Collins, Elizabeth, "Battledress through the centuries," in *Soldiers Magazine*, Defence Media Activity, Secretary of the Army Office of the Chief of Public Affairs, 2013.

• Copeland, Peter. *American Military Uniforms, 1639–1968*. New York: Dover Publications, 1976.

• Davis, Fred. *Fashion, Culture, and Identity*. Chicago: University of Chicago Press, 1992.

• Ford, Tanisha C. "SNCC Women, Denim, and the Politics of Dress," in *The Journal of Southern History*, vol. 79, no. 3 (August 2013).

• Foucault, Michel. *Discipline and Punish: The Birth of the Prison*, transl. Alan Sheridan. New York: Vintage Books (Random House), 1977.

• Foucault, Michel. *The History of Sexuality Volume 1: An Introduction*, transl. Robert Hurley. New York: Vintage Books (Random House), 1990.

• Foucault, Michel. *The Use of Pleasure: Volume 2 of The History of Sexuality*, transl. Robert Hurley. New York: Vintage Books (Random House), 1990.

• Friedman, Vanessa. "The Mess of Modern Power Dressing," in *The New York Times*, March 14, 2019.

• Gaulme, Dominique and François. *Power and Style: A World History of Politics and Dress* (Paris: Flammarion, 2012).

• Givhan, Robin. "Condoleezza Rice's Commanding Clothes," in *The Washington Post* (February 25, 2005), accessed April 2, 2019 <https://www.washingtonpost.com/archive/lifestyle/2005/02/25/condoleezza-rices-commanding-clothes/e7dbedfe-4e60-4e37-a210-ed8733f29d0b/?utm_term=.01bbd4b19cd8>

• Hall, Stuart (ed.). *Representation: Cultural Representations and Signifying Practices*. London: Sage Publications, 1997.

• Hollander, Anne. *Sex and Suits: The Evolution of Modern Dress*. New York: Alfred A. Knopf, 1994.

• Joseph, Nathan. *Uniforms and Nonuniforms: Communication through clothing*. New York: Greenwood, 1986.

• Joseph, Nathan and Nicholas Alex. "The uniform: a sociological perspective," in *American Journal of Sociology*, 77(4), 1972: 719–30.

• Kasturi, Ramya. "Stolen valour: a historical perspective on the regulation of military uniform and decorations," in *Yale Journal of Regulation*, 29(2), 2012: 419–48.

• Klein, Naomi. *No Logo*. New York: Picador, 2000.

• Kwon, Sang-Hee and Ji-Soo Ha. "A study on modern military uniform design," in *Journal of the Korean Society of Costume*, 56(9), 2006: 143–56.

• Lipovetsky, Gilles. *The Empire of Fashion: Dressing Modern Democracy*, transl. Catherine Porter. Princeton, New Jersey: Princeton University Press, 1994.

• Lukes, Steven. *Power: A Radical View*, second edition. New York: Palgrave MacMillan, 2005.

• McNeil, Peter and Giorgio Riello. *Luxury: A Rich History*. Oxford, UK: Oxford University Press, 2016.

• Meixsel, Richard. "A uniform story," in *The Journal of Military History*, 69(3), 2005: 791–99.

• Miller, Daniel. *Material Culture and Mass Consumption*. Oxford, UK: Basil Blackwell, 1987.

• Miller, Daniel. *Stuff*. Cambridge, UK: Polity Press, 2010.

• Morriss, Peter. *Power: A Philosophical Analysis*. Manchester, UK: Manchester University Press, 2002.

• Perrot, Philippe. *Fashioning the Bourgeoisie: A History of Clothing in the Nineteenth Century*, transl. Richard Bienvenu. Princeton, New Jersey: Princeton University Press, 1994.

• Pfanner, Toni. "Military uniforms and the law of war," in *Review of the International Red Cross*, 86(853), 2004: 93–124.

• Rafaeli, Anat and Michael Pratt. "Tailored meanings: on the meaning and impact of organizational dress," in *Academy of Management Review*, 18(1), 1993: 32–35.

• Servin, James. "Chic Or Cruel?" in *The New York Times* (November 1, 1992), accessed April 25, 2019 <https://www.nytimes.com/1992/11/01/style/chic-or-cruel.html >

• Scott, James. *Domination and the Arts of Resistance: Hidden Transcripts*. New Haven: Yale University Press, 1990.

• Steele, Valerie. *Fashion and Eroticism: Ideals of Feminine Beauty from the Victorian Era Through the Jazz Age*. Oxford, UK: Oxford University Press, 1985.

• Steele, Valerie. *Fetish: Fashion, Sex and Power*. New York: Oxford University Press, 1996.

• Stephan, Maria J. and Erica Chenoweth. "Why Civil Resistance Works: The Strategic Logic of Nonviolent Conflict," in *International Security*, vol. 33, no. 1 (Summer 2008), 7–44.

• Trivedi, Lisa. *Clothing Gandhi's Nation: Homespun and Modern India*. Bloomington, Indiana: Indiana University Press, 2007.

• Veblen, Thorstein. *The Theory of the Leisure Class*. New York: MacMillan Company, 1899.

• Weeks, Linton. "Tragedy Gives the Hoodie a Whole New Meaning," on *NPR* (March 24, 2012), accessed May 2, 2018 < https://www.npr.org/2012/03/24/149245834/tragedy-gives-the-hoodie-a-whole-new-meaning >

• Wilcox, Craig. *Badge, Boot, Button: The story of Australian uniforms*. Canberra: NLA Publishing, 2017.

ACKNOWLEDGMENTS

I wish to thank Dr. Joyce F. Brown, President of the Fashion Institute of Technology (FIT) for her support on this project. I would also like to extend thanks to The Museum at FIT's Couture Council for their support of the museum's Fashion and Textile History Gallery.

I am extremely grateful to Dr. Valerie Steele, Director and Chief Curator of The Museum at FIT, for her continued support of me and my work. This book and its accompanying exhibition would not have been possible without her. I would also like to extend a special thanks to The Museum at FIT's Deputy Director, Patricia Mears, Senior Curator, Fred Dennis, and Publications Coordinator, Julian Clark for their unwavering encouragement over the years.

I wish to thank the brilliant contributors who lent their expertise to this project. Robin Givhan, Christopher Breward, Jennifer Craik, and Peter McNeil have each been highly influential on my own work, so it has been a true honor to collaborate with them all on this project. I also wish to thank my friend Kimberly Jenkins for being part of this project. Her work on fashion, race, and social justice is an incredibly important addition to the field of fashion studies, and I am thrilled to be able to include her perspective in this book. A special thanks is due to the designers and brands who were willing to donate their work and images for this project, including Kerby Jean-Raymond of Pyer Moss, Thom Browne, Maxwell Osborne and Dao-Yi Chow of Public School, Grace Wales Bonner, Joy Marie Douglas, Virgil Abloh of Off-White, and Gucci. It is an honor to include your work in this project.

A special thanks is also due to the incredibly talented team at The Museum at FIT: photographer Eileen Costa for her unparalleled work ethic and ability to bring garments to life on film; installation stylist Tommy Synnamon for his keen eye; conservators Ann Coppinger, Alison Castaneda, Marjorie Jonas, and Lauren Posada for their diligence and incredible skill in caring for the museum's collection; Sonia Dingilian and Jill Hemingway of the museum's registrar department for their help overseeing the acquisition of new pieces for this project; Michael Goitia, Boris Chesakov, and Ryan Wolfe for making the installation of the museum's exhibitions possible; Tanya Melendez, Melissa Marra, and Faith Cooper for coordinating all the public events and programming that make the museum accessible to countless visitors; and our media team Tamsen Young and Oyinade Koyi for their ability to make our exhibitions come alive online. I would also like to thank April Calahan in FIT's Special Collections Library for facilitating access to research material that went into this volume.

Edoardo Ghizzoni, my editor at Skira, and his team, deserve special thanks for their work on this book. They produced this book not only with professionalism and insight, but with kindness and encouragement.

I would also like to thank my parents and sister for their amazing support over the years. Finally, I am incredibly grateful to my husband Anant Kumar for his unfaltering patience, love, and support throughout this project. His intellectual curiosity, analytical mind, and unending sense of humor keep me centered and inspired constantly. This book and its accompanying exhibition would not have been possible without you.